SCULPTURE
AT STORM KING

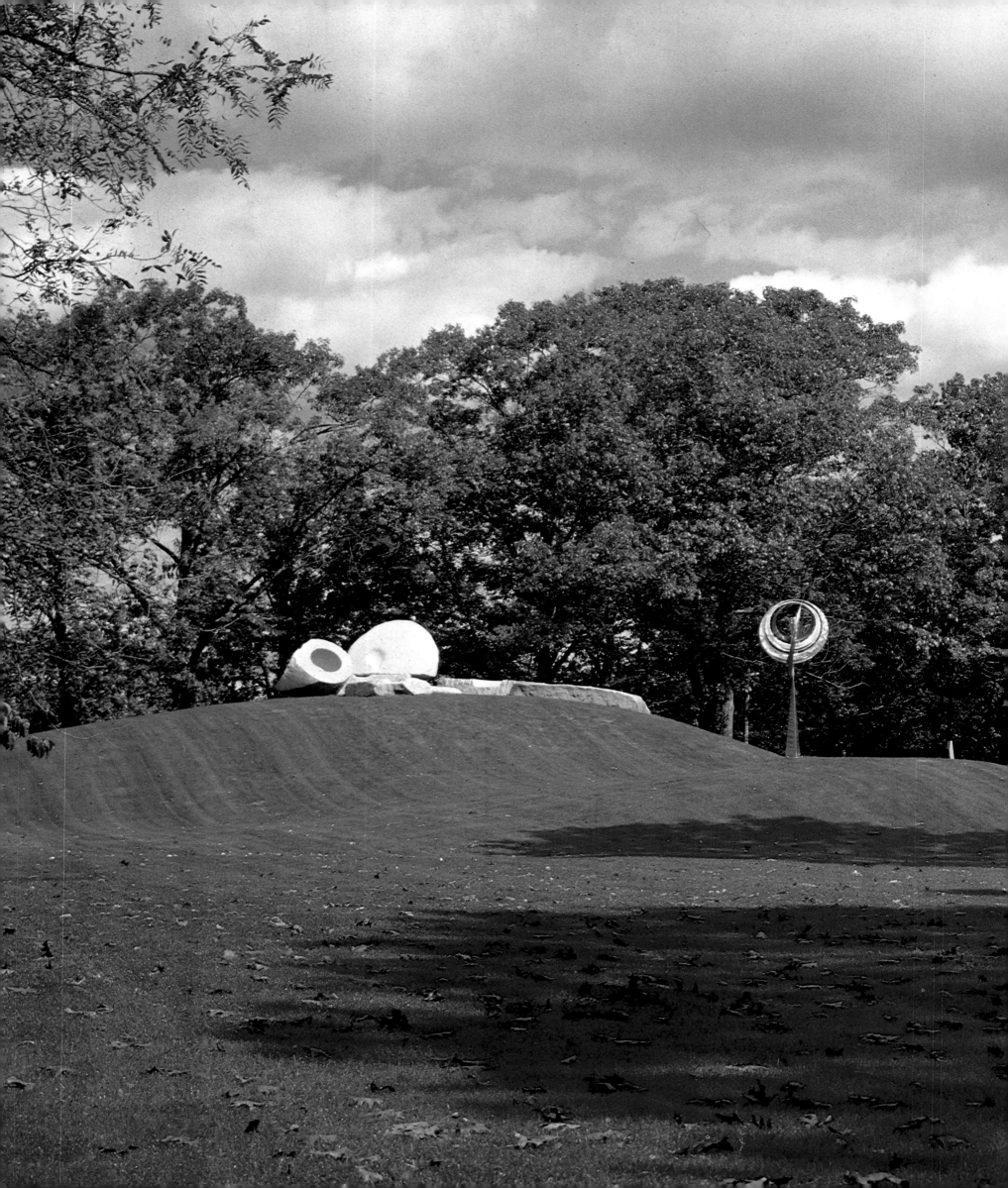

SCULPTURE
AT STORM KING

PREFACE BY
J. CARTER BROWN

PHOTOGRAPHS AND DESCRIPTIONS BY
DAVID FINN

TEXT BY
H. PETER STERN
AND
DAVID COLLENS

ABBEVILLE PRESS INC.
PUBLISHERS · NEW YORK

FOR TED AND PEGGY OGDEN

ALL SCULPTURES ILLUSTRATED ARE IN THE PERMANENT COLLECTION OF THE STORM KING ART CENTER, EXCEPT THE FOLLOWING:

ALEXANDER CALDER
Museum of Modern Art, New York, Gift of the Artist, 1966: *Sandy's Butterfly*
Estate of Alexander Calder and Knoedler Gallery: *The Tall one, Flamingo, The Arch*

MARK DI SUVERO
Lent by the Artist and Richard Bellamy: *Are Years What? (for Marianne Moore), One Oklock, Mother Peace, Ik Ook, Mon Père Mon Père.*

JIM HUNTINGTON
Anonymous Loan: *Inheritor (for Jake)*

ALEXANDER LIBERMAN
Anonymous Loan: *Ascent*
On Loan from the Artist: *In, Iliad*

Designer: Ulrich Ruchti

Library of Congress Card Catalogue Number: 79—89157

ISBN 0-89659-083-6

CONTENTS

PREFACE

Storm King Art Center is a remarkable American institution. As a museum devoted to contemporary sculpture, it is outstanding; as an "outdoor" museum it is innovative and imaginative; as an open-air sculpture museum of 200 acres — most of them given over to the careful display and juxtaposition of large monumental pieces — it provides an extraordinary setting for a fine collection of major works.

There are, of course, small patches of ground here and there throughout the country where outdoor sculpture is on display. The landscape and town squares of America have long been dotted with statues commemorating battles, war heroes, and city fathers. More recently, civic and cultural plazas, shopping centers, and corporate headquarters have become hospitable to the work of more serious sculptors. The East Building of the National Gallery is graced by a fine Henry Moore sculpture at its entrance; and several other museums, like the Modern in New York and the Hirshhorn in Washington, have gardens where a variety of pieces may be seen together.

But none of these situations or collections approaches that of Storm King; and thus it is a special pleasure to see Storm King introduced to a larger audience through the pages of this book.

My own association with this remarkable museum has several facets. I came to know its President, H. Peter Stern, through our joint work on the International Fund for Monuments and its activities on behalf of such sites as Venice, Easter Island, and the Coptic churches of Africa.

Then, in planning exhibitions for the inauguration of the East Building of the National Gallery, it was natural to look to Storm King for a major loan. The result was the selection, for a site on Constitution Avenue, of Alexander Liberman's "Adam" — a piece which complements handsomely I. M. Pei's design for the new building.

Finally, in the fall of 1977, I was invited to join the board of the Storm King Art Center; and I gladly accepted. It is as a member of that board that I invite you, in turn, to enjoy the museum's riches — as revealed in David Finn's photographs.

J. Carter Brown
Director
The National Gallery of Art
Washington, D. C.

INTRODUCTION

Storm King Mountain, despite its name, overlooks a peaceable kingdom of forest and farmland above West Point in the Hudson River Valley. Among those who chose to live and work in the area were two remarkable individuals: Vermont Hatch and Ralph E. Ogden.

In 1927 Monty Hatch purchased property in Mountainville, 60 miles north of New York City. Shortly thereafter he built a replica of a French Normandy-style chateau as a country house in this valley between Storm King and Schunnemunk Mountains. When he died in 1958, his long-time friend and neighbor, Ted Ogden, decided to buy the property to keep it undivided and preserve its natural beauty.

Like his father, who had started Star Expansion Industries Corporation in 1903, Ted Ogden was a businessman. However, his greatest love was for the land. He had grown up in the rural ambience of Mountainville, where he had acquired a good deal of farmland. Here he raised crops for his prize herd of Holstein cattle. In the 1950's he further committed himself to the region by building a factory and moving the family business to Mountainville from its previous locations in Bayonne, New Jersey and New York City.

As he retired more and more from active management of the company, Ted Ogden turned his attention to travel and to art. He began collecting, aided by his wife, Margaret, herself a collector and great-niece of the painter Thomas Hovenden. The purchase of the Hatch estate coincided with the discovery of this new found passion, and the Storm King Art Center opened its doors in the summer of 1960.

One of the first exhibitions was devoted to the work of Winslow Homer, who had completed a series of paintings during a summer spent in Mountainville. Subsequently, the idea of converting the Center into an open-air museum for sculpture was inspired by photographs of the Henry Moore sculptures on Sir William Keswick's sheep farm in Glenkiln, Scotland. In 1961, while travelling in Austria, Ted Ogden visited a quarry near the Hungarian border, and after purchasing a number of sculptures, done on-site as part of a contest sponsored by the Austrian government, he became engrossed by the challenge of locating them outdoors. In the next few years, the acquisition and placement of outdoor sculpture became the focus of his life as a collector — and of the Storm King Art Center.

In 1967, upon the urging of friends, he went to Bolton Landing in upstate New York to inspect the work of the late David Smith. He decided to buy, but to do so in a big way: thirteen Smith pieces of the 50's and 60's were purchased all at once. Of the group of thirteen pieces, eight larger works are located outdoors similar to Bolton Landing, and five of the more delicate sculptures are situated in the Museum building. These works constitute a significant nucleus of Smith's work.

The presence of these works at the Center created a wide interest in Storm King.

Other important purchases followed, and Ted Ogden continued his active interest in the Art Center until his death in 1974. At that time the collection of over one hundred sculptures included works by Calder, Caro, di Suvero, Ginnever, Grosvenor, Hepworth, Moore, Rickey, Von Schlegell and Witkin, to name but a few of the many artists represented.

It has been my privilege to be president of the Storm King Art Center from its beginning. Ted Ogden and I had an unusually close friendship and business relationship. For over 20 years I have been president of Star Expansion Industries Corporation in Mountainville.

Although I spent my childhood in Europe, my love for the area around Mountainville has found expression in many artistic and educational projects, which have included service on such boards as Vassar College, The Hudson Valley Philharmonic, Storm King School, Museum Village, and Mid-Hudson Pattern, a regional planning and conflict-resolution group with representatives from all segments of the community. But my greatest interest in the last few years has been the Storm King Art Center.

From the outset I shared Ted Ogden's feeling that the choice or creation of a site was an important adjunct to the selection and acquisition of the sculptures, and the brief history of Storm King has therefore been a busy one of growth, change, and location of sculptures. New acquisitions have necessitated the thinning out of wooded areas, the altering of slopes, the building of knolls and paths.

As the landscape changes, so do the relationships among the sculptures. New installations suggest more appropriate locations for previous acquisitions. Part of the excitement of Storm King is this continuing dialogue between the land and the art, between one work and another.

The sculptures in our collection have been placed in sites which are selected and often specially created to meet the requirements imposed by the scale and media of the pieces. Works of smaller scale are suited to more formal locations nearer the building, sculptures of monumental size are seen at their best in the open fields. In winter, some come indoors, some are wrapped up like rosebushes, others stand happily against the elements.

The management of an art center like Storm King means constant attention to both aesthetic and technical details. Not every artist knows a good bolt from a bad one, an all-weather metal paint from kitchen-cupboard enamel. The short history of the Art Center has included its share of exchanging information with artists along such lines. Star Expansion, with its expertise in metallurgy due to its production of metal fasteners, has contributed valuable engineering knowledge in such matters.

Maintenance of a 200-acre outdoor sculpture museum provides its own set of problems and opportunities. In earlier years, for example, concrete pads had been

laid as underpinnings to the sculptures. To keep lawn mowers from bumping into the works, these pads were necessary to hold the grass at a distance. Unfortunately, they also disconnected the art from the earth — at least visually. The introduction of nylon-line high-speed trimmers has made it possible to remove or bury most of the concrete slabs, to let the grass grow right up to the sculptures themselves — without sacrificing a well-trimmed look where appropriate. Thus have minor advances in the technology of groundskeeping made possible major changes in the aesthetics of Storm King.

The most exciting aspect of managing such a center remains the building of the collection. In the last few years we have concentrated on a few large-scale works by recognized masters. In 1975 we acquired Kenneth Snelson's "Free Ride Home," locating it on a specially shaped knoll. In 1977 we commissioned Isamu Noguchi to create a major sculpture at a specially contoured site overlooking the Art Center and the surrounding countryside. "Momo Taro" was created by Noguchi in his studio on the island of Shikoku in Japan, with granite from the neighboring island of Shodo Shima. The piece consists of nine massive stones which were brought to the Art Center from Japan in May of 1978 and embedded in the hilltop site previously prepared for them. A unique aspect of the piece is that the stones are shaped so as to invite visitors to sit upon and among them. One stone is hollowed out so that a visitor may actually sit inside of it. We have also acquired, with the support of matching funds from the National Endowment for the Arts, works by established as well as younger sculptors, some of them designed for a special site or built at the Art Center. Among the artists whose works have been acquired in this manner are: Bourgeois, Ferber, Frank, Friedberg, Kipp, Perlman, Stankiewicz, Streeter, Trova, and Westerlund.

Loans have always served to supplement the sculptures that make up the permanent collection; and in recent years extended loans have become particularly important to Storm King. Five of the monumental di Suveros which were included in his 1975 retrospective in New York now stand in the shadows of Storm King and Schunnemunk mountains. Other extended loans include a number of large Alexander Liberman sculptures. These originally formed part of the 1977 retrospective exhibition, which also included 150 of his drawings, paintings, photographs, and indoor sculptures.

In 1979 the estate of the late Alexander Calder generously arranged to lend us three of his works, including "The Arch." This work, completed in 1975, is one of his major monumental pieces and stands over fifty feet high.

The responsibility for the annual exhibitions, including the Liberman and Smith retrospectives with displays both inside the building as well as on the grounds, rests with David Collens. He joined the Storm King Art Center staff in the fall of 1974, and became Curator in 1975. He was appointed Director in 1978. His remarkable "eye" — his feeling for matching site and sculpture — is well known in

From its inception, the Art Center has enjoyed the enthusiastic support of a
the art community and has impressed every artist who has worked with him.
large number of individuals. In 1978, the Board voted to inaugurate the "Friends of
the Storm King Art Center" program, designed to promote broader public partici-
pation.

H. Peter Stern
President

THE COLLECTION

Because of its open-air situation, acreage, and sculptural focus, Storm King has no equivalent in the United States. If it bears any resemblance at all to other art institutions, they are found overseas: The Louisiana Museum in Denmark; the Kröller-Müller in The Netherlands; Millesgarten in Sweden; the Vigeland Sculpture Park in Norway; the Billy Rose Sculpture Garden in Israel; the Hakone Open-Air Museum in Japan.

But most of these are primarily urban in feel and scale. Storm King has the advantages and space of a genuinely rural landscape in which to place contemporary sculpture. Still, ruralness does not mean mere rusticity. The Storm King landscape is composed of a diversity of settings, ranging from the building's formal gardens to open fields and wooded areas.

Nearest the museum building are the smaller, more formal sites—hedge-trimmed lawns, gardens, patios, and alcoves formed by the architecture. In the midst of shrubs, paths, and pachysandra are suitable locations for the more self-contained, introspective works in the collection. Max Bill's "Unit of Three Elements," the interlocking shapes of Helaine Blumenfeld's "Dependence," the blossomlike form of the Hepworth bronze—all these are works whose energy is matched by their reserve. They do not reach out to dominate great areas of landscape, and thus are appropriate to their sheltered situations.

The Bill, for example, despite its thrusting lines, is held in tightly by its scale organization and centeredness. Its dark, polished black marble surfaces further efface themselves through their reflections of leaf, sky, and shadow.

Near the museum building, too, is the formal garden space set aside to contain the David Smith collection. The variety among these works, their openness and delicacy, make them a bouquet unto themselves. (The most delicate of these works are not even out-of-doors, but displayed inside the museum—along with the yearly changing exhibitions.)

As one moves out and away from the museum, the lawns begin to undulate more freely; the spaces between trees begin to open up, as do the vistas to the surrounding countryside. Larger, more commanding works find their proper spheres, even while remaining in sight of—and in easy reach of—the museum.

In this middle distance are works like Henry Moore's "Reclining Connected Forms," Calder's "Seven Foot Beastie," and Witkin's "Masai." The largest work close by the building is Snelson's "Free Ride Home"—its suspended aluminum tubing hitting off an appropriate balance between a more aggressive scale and the inwardness of its part-to-part relations of cable and cylinder.

At the far edge of the lawn to the northeast is the knoll from which Noguchi's "Momo Taro" looks back toward the museum and northward to such monumental

pieces as Liberman's "Ascent," "Eve," and "In" — and also to such hillside and woodside works as Gilbert Hawkins's "Four Poles and Light" and Forrest Myers's "Four Corners."

Farthest from the museum building — and nearest the entrance gate — are another large Liberman, "Adonai," and Tal Streeter's "Endless Column" — the latter, in particular, profiting from its site in an open field, its unencumbered "sky's-the-limit" space.

On the opposite side of the entrance drive is an even larger open field — a cornfield, in fact, until recently. Across its northern edge stretches Grosvenor's 204-foot-long "untitled" black bridge. Closer in, by the fences, Sol LeWitt's reserved, white "Five Modular Units" plays off against the explosive qualities of Liberman's "Iliad" — bright orange against the green of grass and leaf.

This larger field wraps around the hill on which the museum building is located. At the base of that hill — and visible from the lawn and parking area above — are the three open, airy cubes of Von Schlegell's untitled piece of 1972; and at the south end of the property five massive di Suveros stride across the landscape like giants, dwarfing the mountains beyond. These include "Are Years What? (For Marianne Moore)," "Ik Ook," "Mon Père, Mon Père," "Mother Peace," and "One Oklock." To the east of these are two additional works by Von Schlegell. These are also visible from the hill above them, most notably from the area near the David Smith garden.

Elsewhere near the building are several pieces which frame the landscape and the sculptures below — Trova's "Gox No. 4," for example, or Myers's "Mantis," or Ginnever's "Fayette: For Charles and Medgar Evars." The latter, playing with optical illusions anyway, calls attention to the shifting sense of scale made possible by the distances available at Storm King. The large di Suveros fit meekly inside the small opening of the Ginnever piece, when viewed from the hill above.

The varied terrain of Storm King — its contrasts of open field, wooded hillside, formal lawn — provides an ideal circumstance for meditation on the various interactions of art and landscape. Hawkins's poles play off the straight trunks of the pine grove beyond them, but in a way vastly different from William Tucker's "Six Black Cylinders," on the other side of the same grove. If the Grosvenor piece turns one's thoughts to the horizontality and breadth of earth and field, Streeter's "Endless Column" across the road from it directs the eye and mind vertically toward the open sky.

Besides their various interactions with the topography, works which are exhibited out-of-doors undergo endless changes of light. Not only the hourly alteration of shadows as the sun moves, but the altering moods of high noon and dusk, sun and storm, spring and fall. The seasons, like the weather, continually redefine the works. The sculptures in their turn bring these changes to life by directing attention to them and energizing their aesthetic potential.

One of the altered aspects of outdoor sculpture since its blossoming in the Renaissance is made most apparent at Storm King. Much of the earlier use of

outdoor work was decorative, an extension of the decorative role assigned to sculpture in architectural surroundings. The purpose was enhancement of the site, not the declaration of three-dimensional ideas and feelings with site as a supportive element.

In a way related to this decorative subjugation of the sculpture of park and garden, statuary in the city square had a communal function which often outweighed its contemplative value. What was usually defined was not so much a space as a sponsor.

Since the Renaissance we have seen the gradual evolution of monumental sculpture from its beginnings as decorative adjunct or socio-cultural token into an independent aesthetic object. The aim of Storm King in particular is to give a large number of such works — and related smaller ones — the freedom and situation necessary to that independence.

The result has been the development of a unique museum, a unique opportunity to see and exhibit contemporary sculpture in a setting equal to its demands on attention — an opportunity which still allows one to judge such pieces in relation to others — by the same or by different artists.

Two hundred acres seem little enough space to march through — or administer — when these purposes are understood. The great disadvantage of smaller museums is thus avoided: that of trying to give adequate representation and occasion for comparison, without the concomitant overcrowding.

I consider it my good fortune to be associated with an institution where some of these "ideal" conditions have been realized, and to have the support of a Board which shares the aesthetic vision upon which such realizations depend. I have a truly close and personal working relationship with Peter Stern, as I did with the late Margaret Ogden, wife of Storm King's founder, and herself an active Trustee. Ted Ogden's daughter, Joan Ogden Stern, a former trustee, continues to participate in the work of the Art Center as a patron. The generous support of the Trustees has helped shape Storm King; and I have every reason to expect a future for the Art Center as exciting as its past and present.

The present is what the following photographs reveal, however; and it is hoped that the future can be more easily imagined and more enthusiastically shared by a wider audience with their help.

David Collens
Director

PHOTOGRAPHING AT STORM KING

The placement of sculptures at Storm King is a fluid process, with locations changing from season to season as new works are added to the collection or borrowed for special exhibitions. Always the slope of the ground, the shape of the foliage, the view from different vantage points, the position, character, and requirements of neighboring sculptures, are taken into consideration when locating a new work or relocating sculptures from the permanent collection. Placement decisions are made with the utmost care and sensitivity so that each sculpture can be seen and experienced by itself in what is hoped will be an ideal environment.

This presents a breathtaking opportunity for a photographer, for one can move about Storm King, in spring or summer or fall (as I have done), discovering the shapes and colors and textures of a beautiful landscape and skyscape intermingling with the widest variety of sculptural forms. Storm King provides a superb setting for these works, but each individual can have his own visual adventure as he wanders across the land and picks out the special views which attract his eye. The camera becomes an instrument to record these personal discoveries and reproduce them for later enjoyment.

Some of the sculptures shown on the following pages are no longer located where I photographed them. My descriptions, therefore, refer to my impressions of the environment in which I saw the sculptures through my lens at that time, and not necessarily where they are today. If their positions are now different, one's perceptions may be altered, but not diminished.

As it happens, I have photographed sculptures in many of the well known open-air sites around the world—in Japan, Israel, Germany, Holland, Belgium, England, Scotland, Ireland, and many parts of the United States; and I have never seen any environment to compare to Storm King. What distinguishes this remarkable outdoor Center from all the other sites is that so many sculptures are placed so well, giving the visitor a great deal to see without being confused or distracted by overcrowding. All who love sculpture can find in Storm King an excellent selection of recent works in the finest surroundings one can imagine.

David Finn

LIST OF ILLUSTRATIONS

SCULPTURE
AT STORM KING

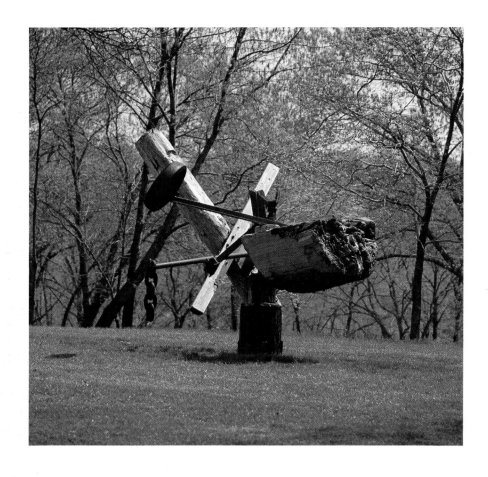

The solidly balanced forms and textures of "Pre-Columbian" by Mark di Suvero (above), are handsomely set off by the network of branches in the background; while on the slope of a hill beyond, the slowly rotating arcs of "Orbit" by Jerome Kirk (facing page) reflect the light of the sun. Resting on the crown of the hill beneath the vaulted arches of the overhanging trees are the ancient rocks shaped and hollowed for "Momo Taro" by Noguchi (overleaf).

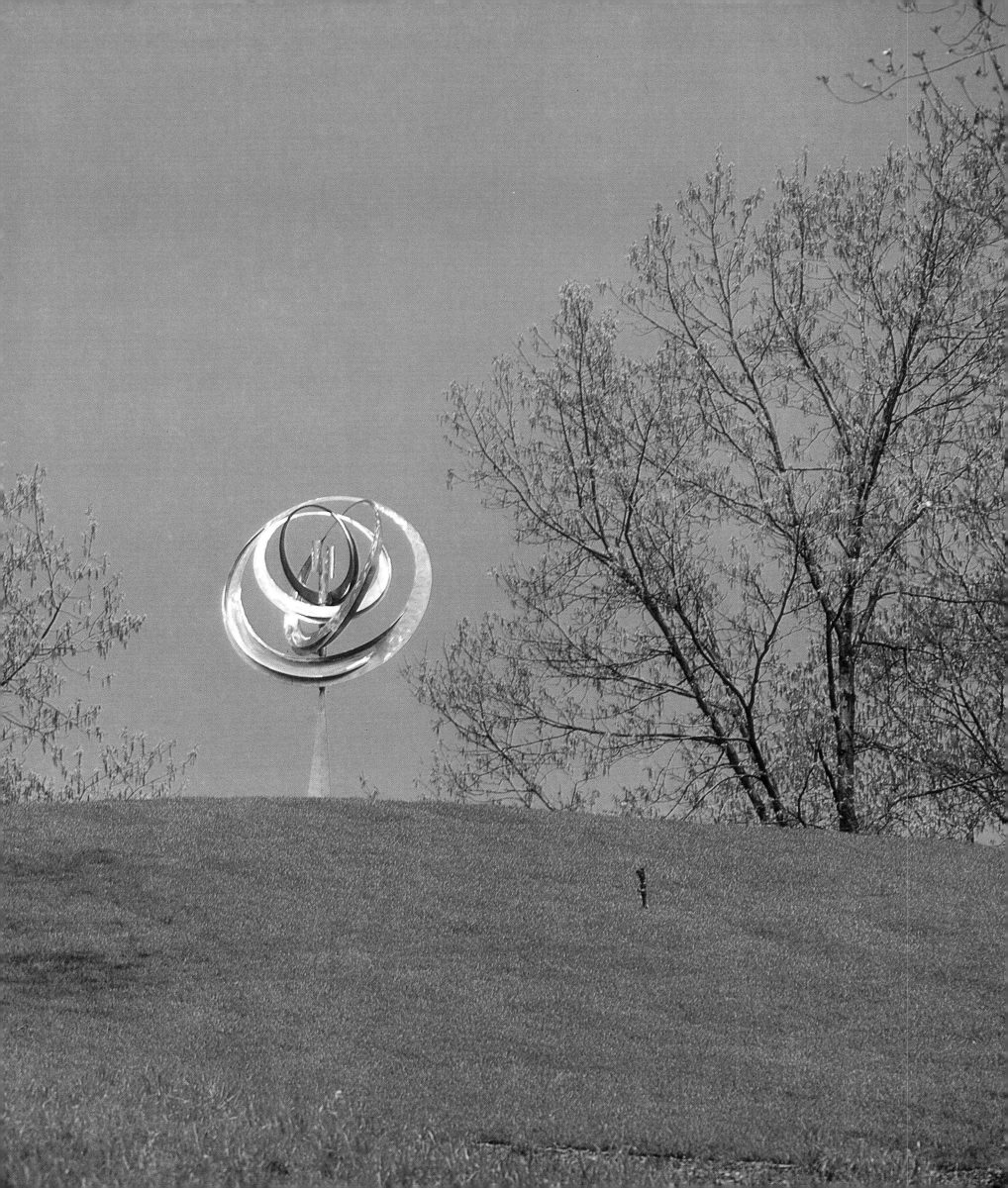

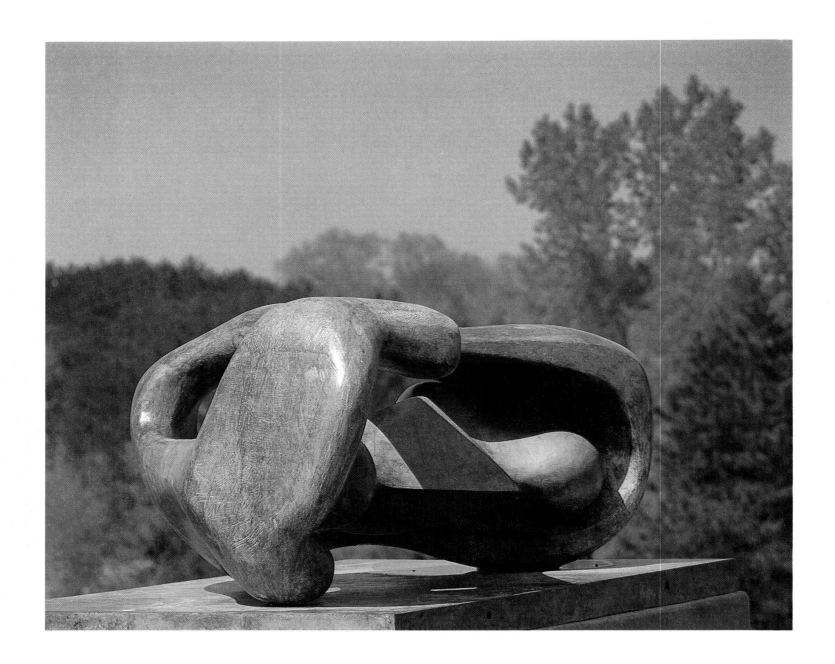

The bright sunlight helps to
define the organic forms of
Henry Moore's "Reclining
Connected Forms" (above)
and underline Barbara Hep-
worth's cascading "Square
Forms With Circles" (facing
page).

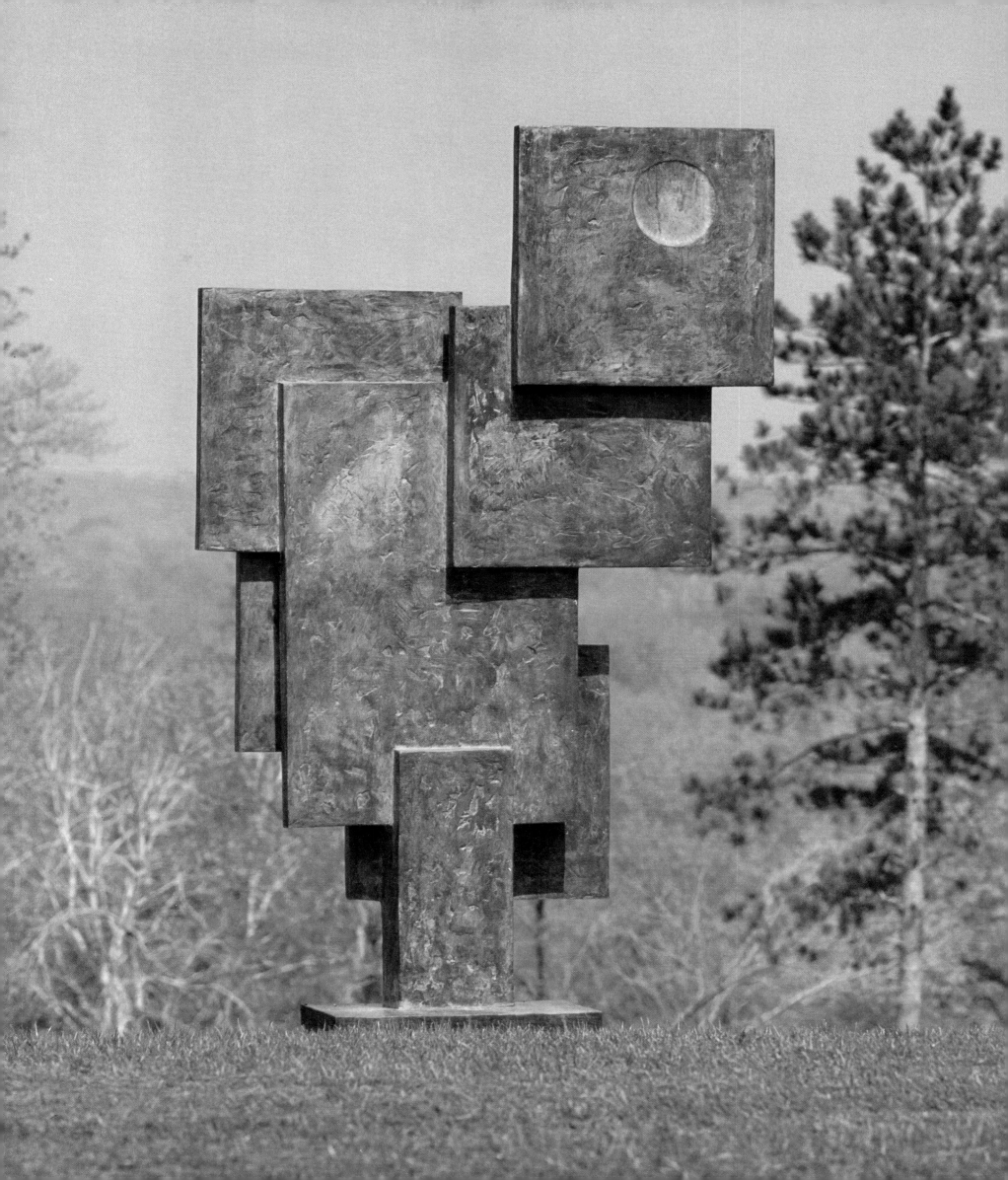

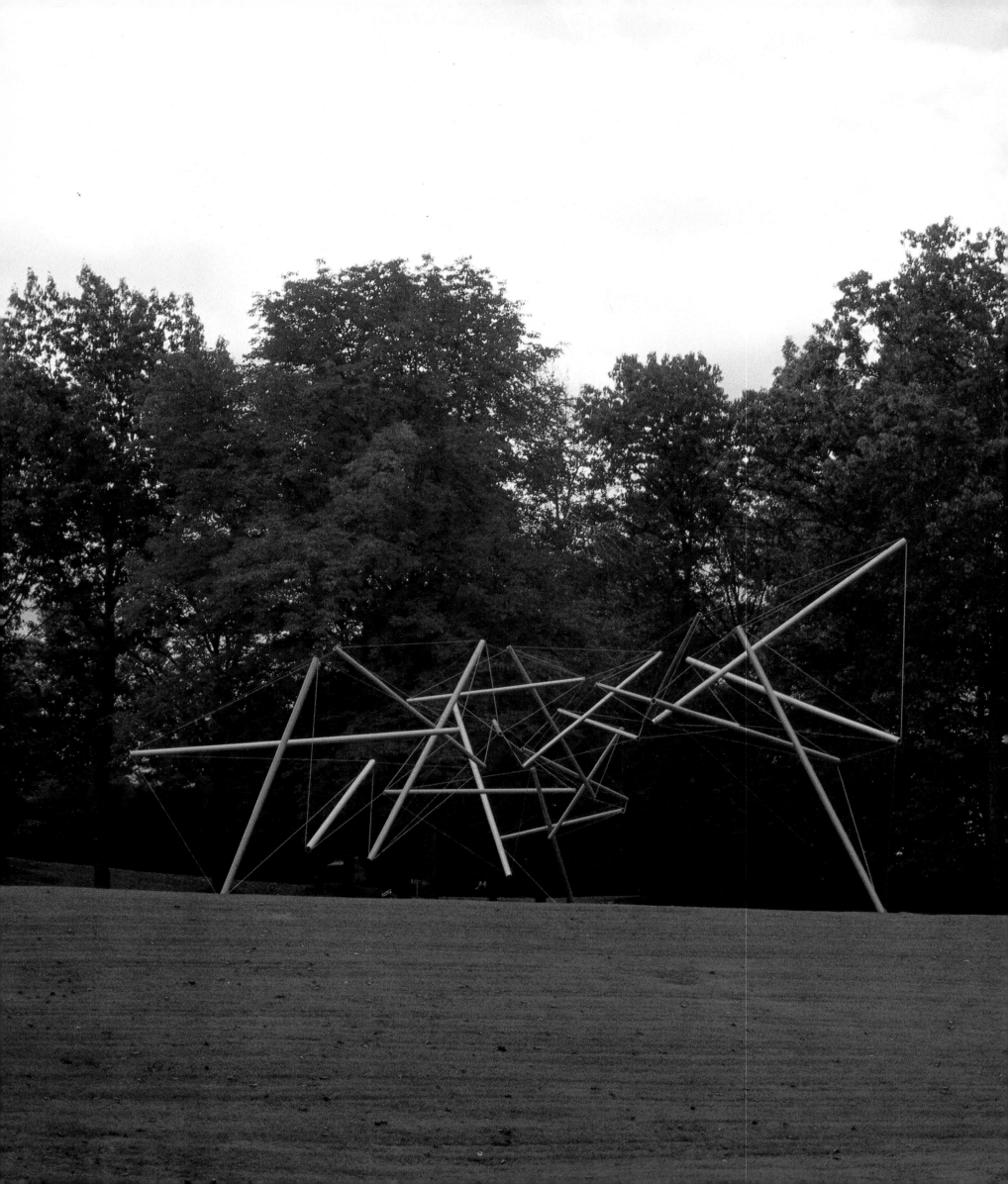

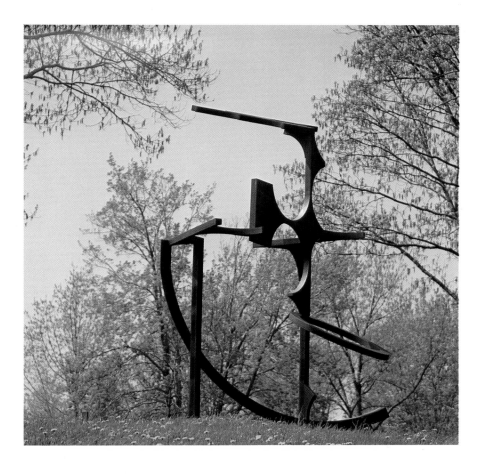

The taut, suspended tubes of Kenneth Snelson's "Free Ride Home" (facing page) are erected in a large space surrounded by trees, projecting its bright aluminum cylinders against the dark foliage.
Nearby, the inventive shapes of Isaac Witkin's "Kumo" (left) intermingle with delicate branches and leaves.
A family of boulders, "Spheres" by Grace Knowlton (below) rests securely in the flat of the meadow.

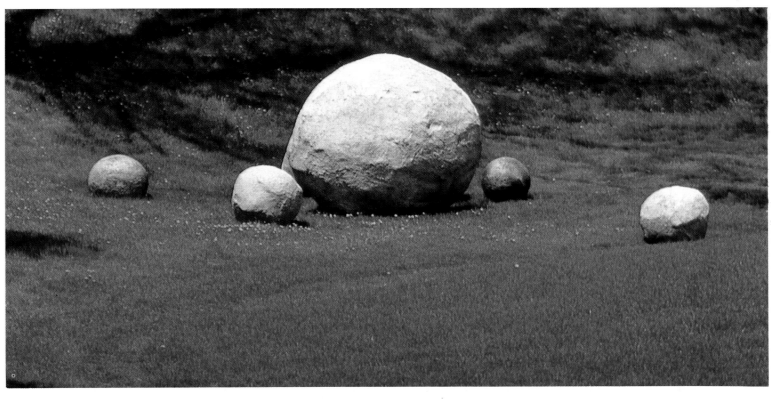

The "Untitled" circle and two rectangles by David Annesley (right) cut into the bushes and echo the distant hill, while the curved lines in "Parenthetical Zero" by Michael Todd (lower right) barely emerge from the deep shade. Alfred Hrdlicka's strong male figure "Golgatha" (lower left) stands boldly against the hill.

A giant triangular structure of stilts, "Four Poles and Light" by Gilbert Hawkins (facing page) is the natural companion of the straight tall pines behind.

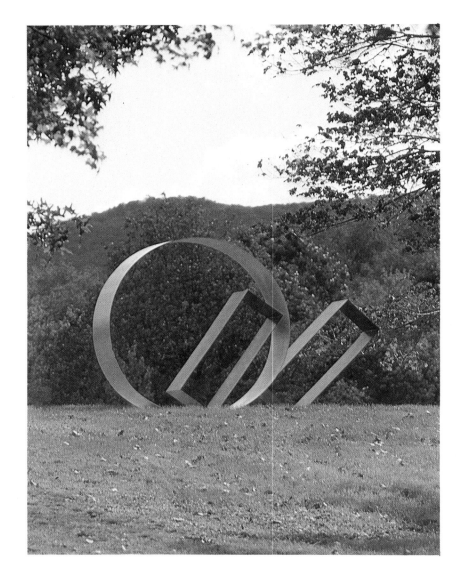

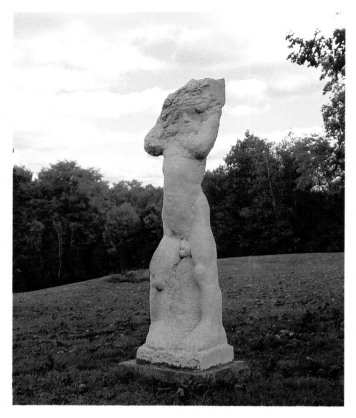

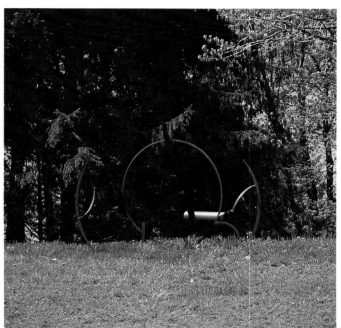

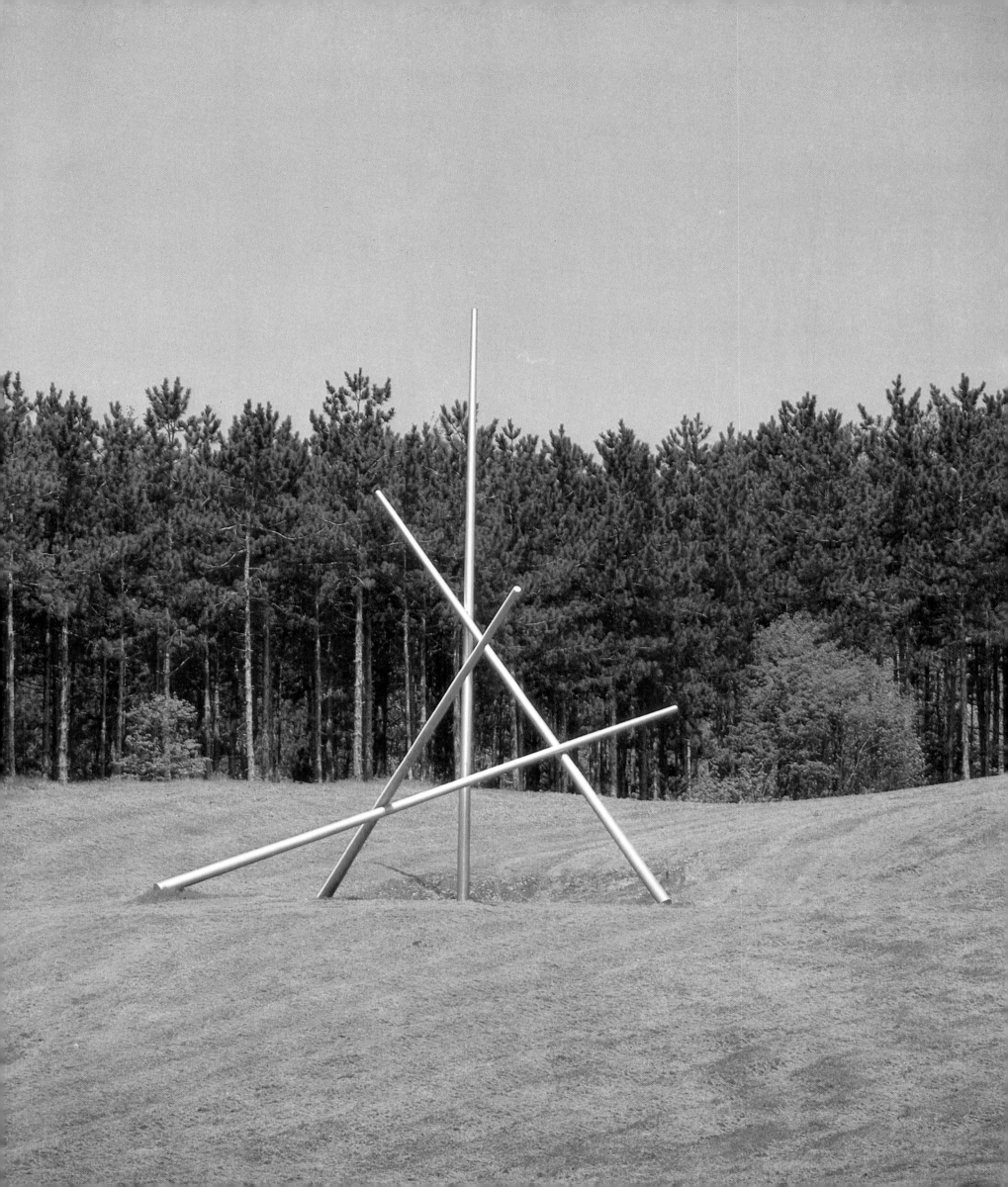

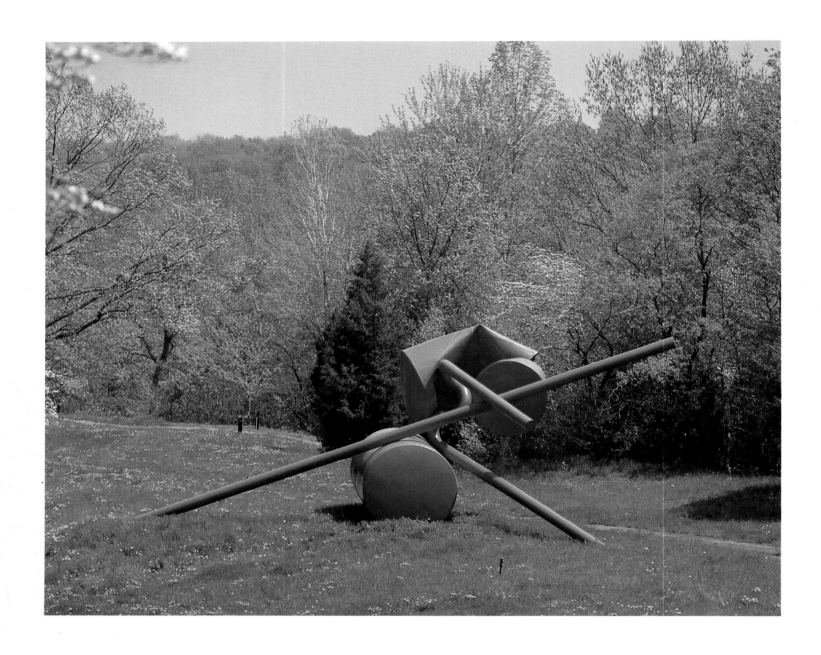

The bright, bold orange of
Alexander Liberman's "Eve"
(above) levers into the sur-
rounding green.
A well-constructed and neatly
creased "Ascent" by Liberman
(facing page) guards the top
of the hill.

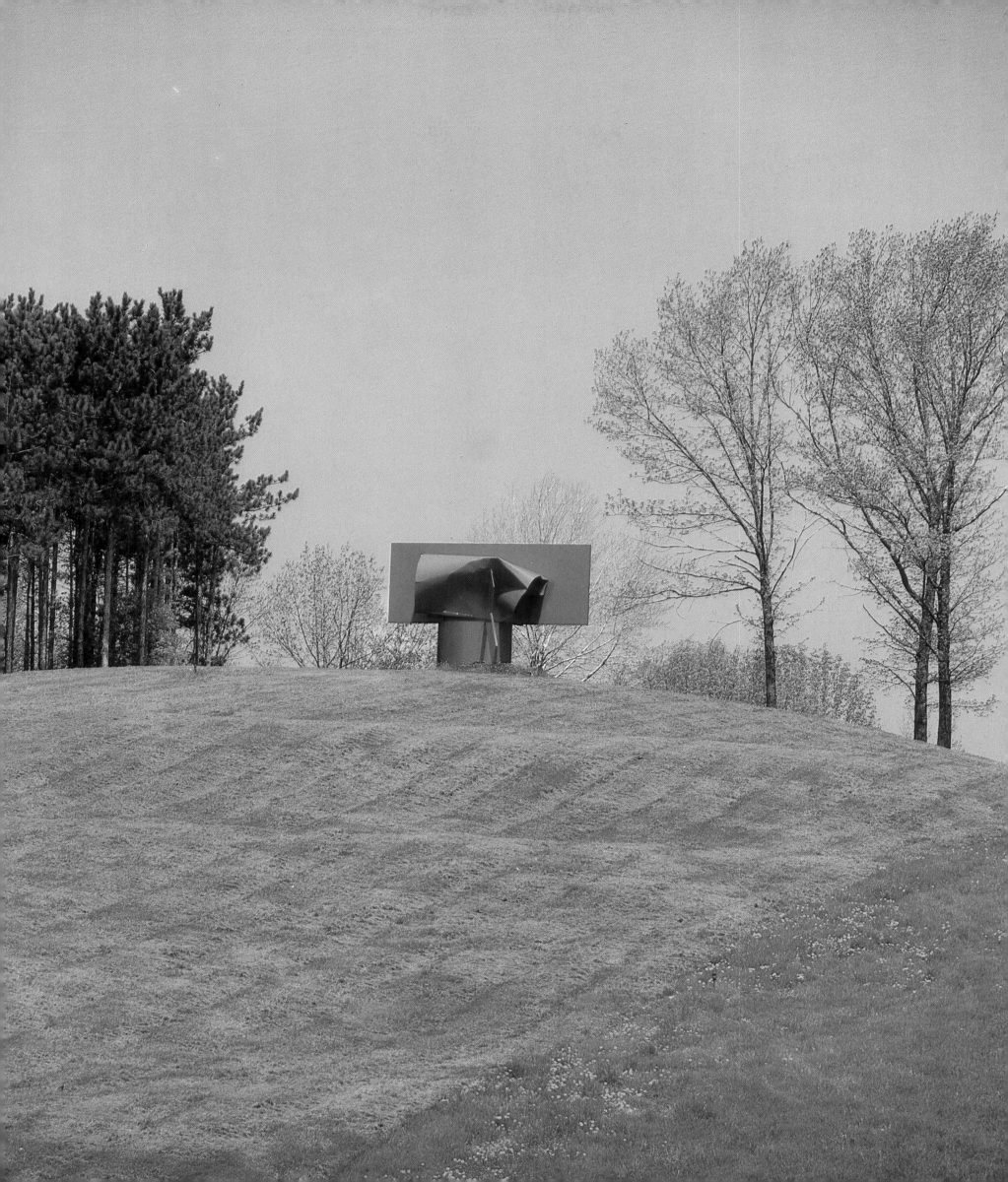

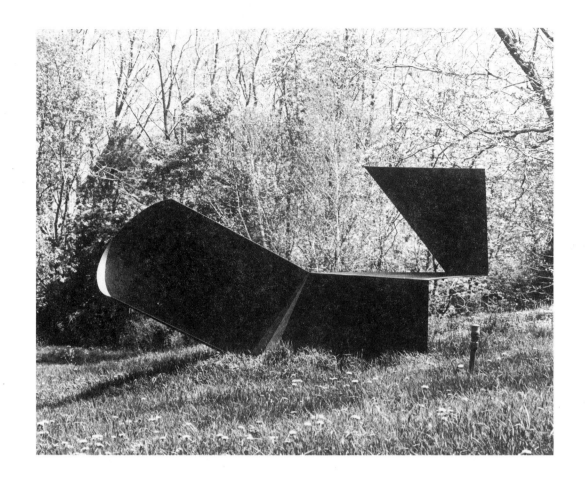

In the distance one sees the black/white right angles of "Four Corners" by Forrest Myers (facing page left) and the tall broken "Column" by Gerald Walburg (facing pagé right). Precariously balanced, the cut-out shapes of "Shogun" by Isaac Witkin (left) and the boxed forms of "1971" by Charles Ginnever (below) rest on grassy slopes.

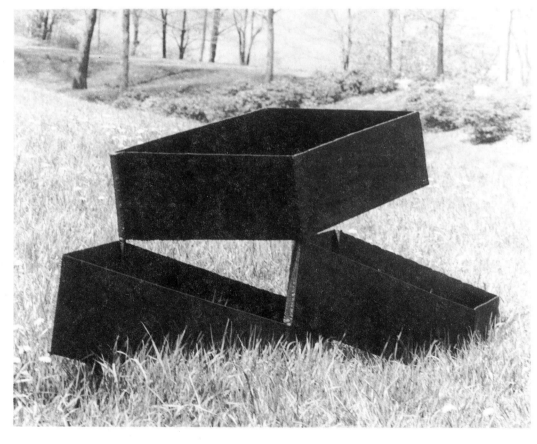

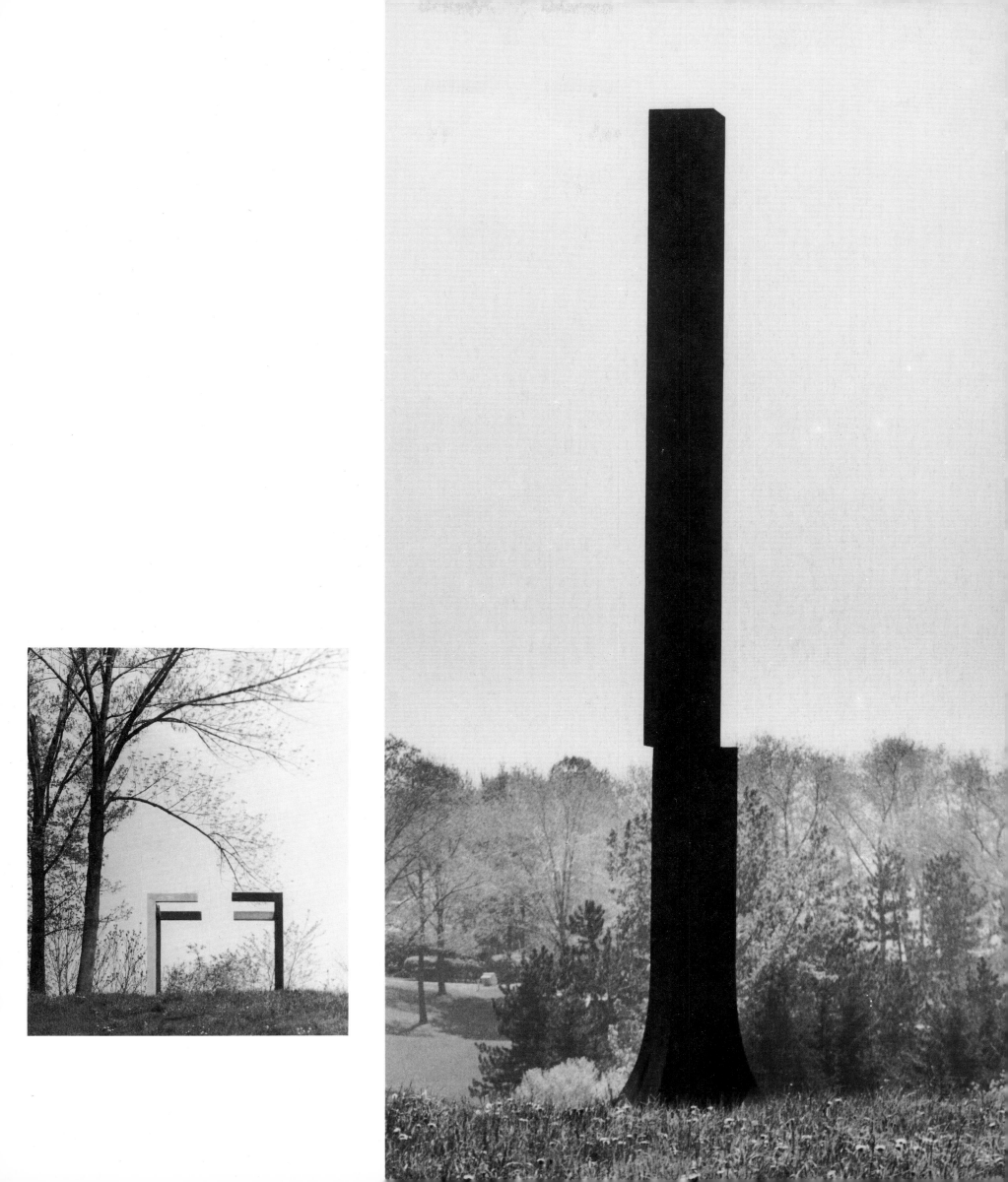

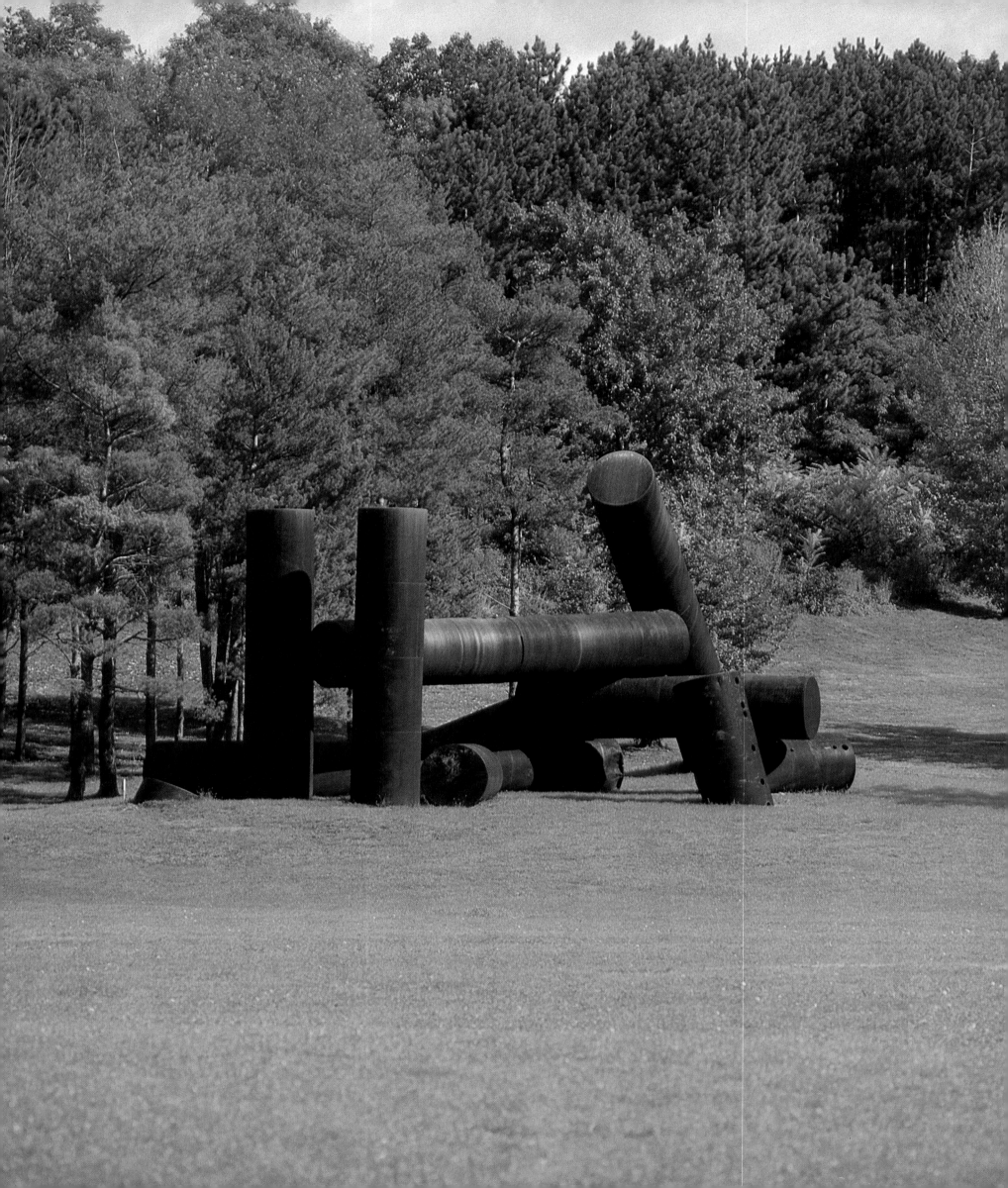

A sawtooth cutting into the heights above, Tal Streeter's "Endless Column" (right) towers over the distant trees. A marker against the sky, it carries the eye upwards to watch the movement of clouds.

One of Alexander Liberman's sturdiest constructions, "Adonai" (left) stands as a sentinel at the far end of an open field.

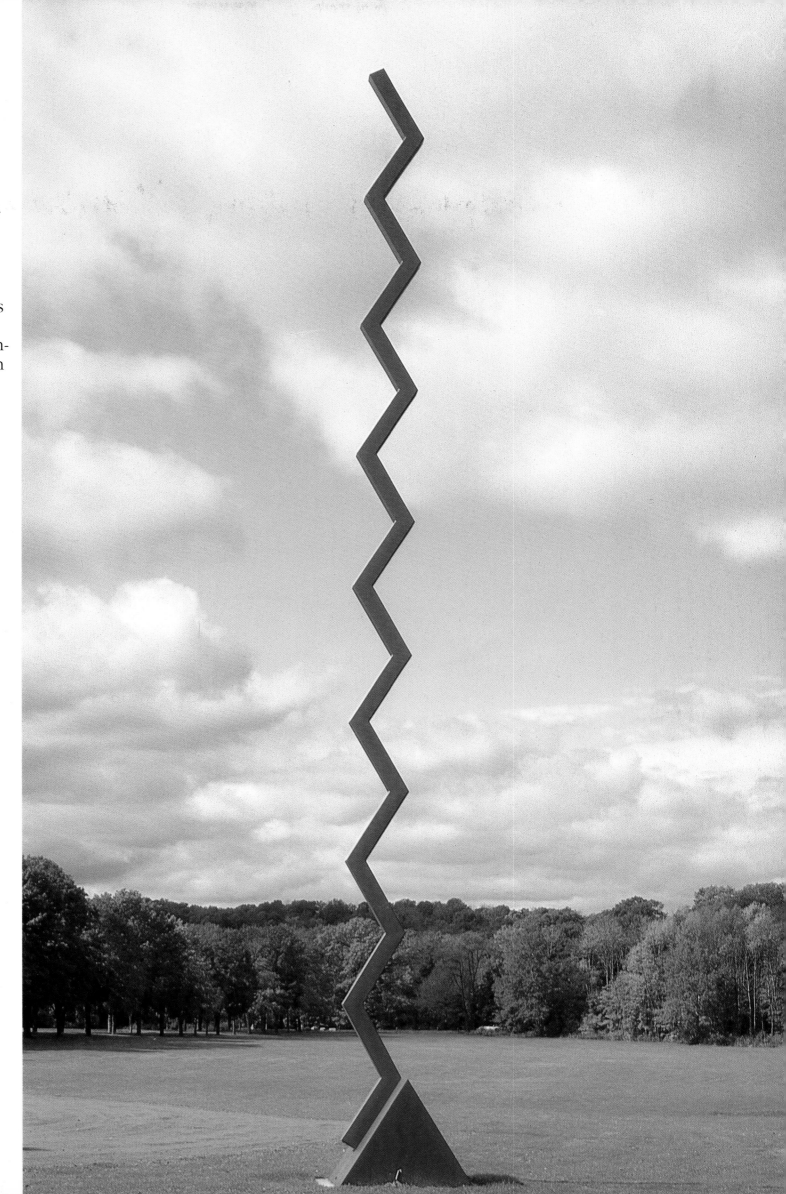

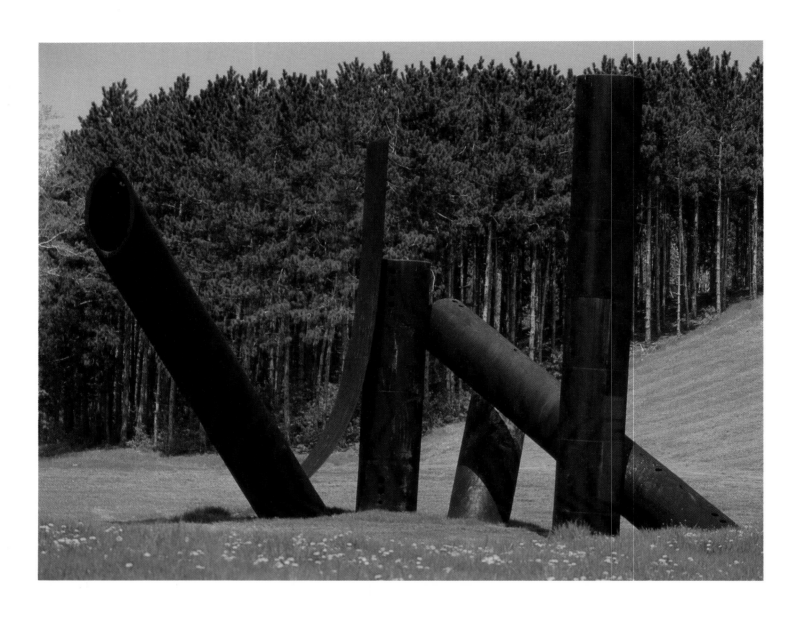

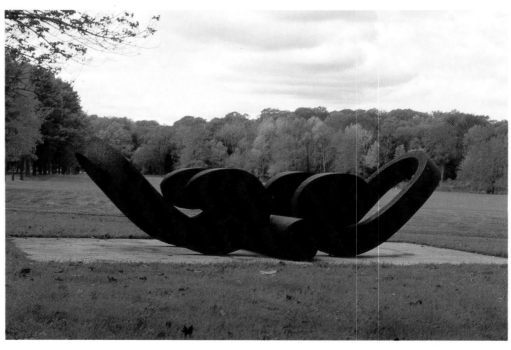

44

Low-lying forms create a family of curves and angles that accent the green fields and foliage.

"In" 1973 by Alexander Liberman (facing page above)

"Loops V" by Gerald Walburg (facing page below)

"Man in the Quarry" by Josef Pillhofer (right)

"River Run" by David Stoltz (below)

"The Arch" by Alexander Calder is a majestic stabile, rising over fifty feet into the air. This is the last large-scale sculpture completed by the artist before his death. Its sweeping black forms, graceful and monumental, are firmly planted at the far end of a large open field and tower over the treetops in the distance. Also included in the 1979 exhibition are Calder's "Seven Foot Beastie," (page 49) with its angular points thrusting skyward, and "The Tall One" (page 48), its round head proudly standing on its long stem. In addition, there is the array of colorful cut-outs, "Sandy's Buttererfly" (page 51) and "Flamingo" (page 50), the dancing form that looks as if it could move across the grass with ease.

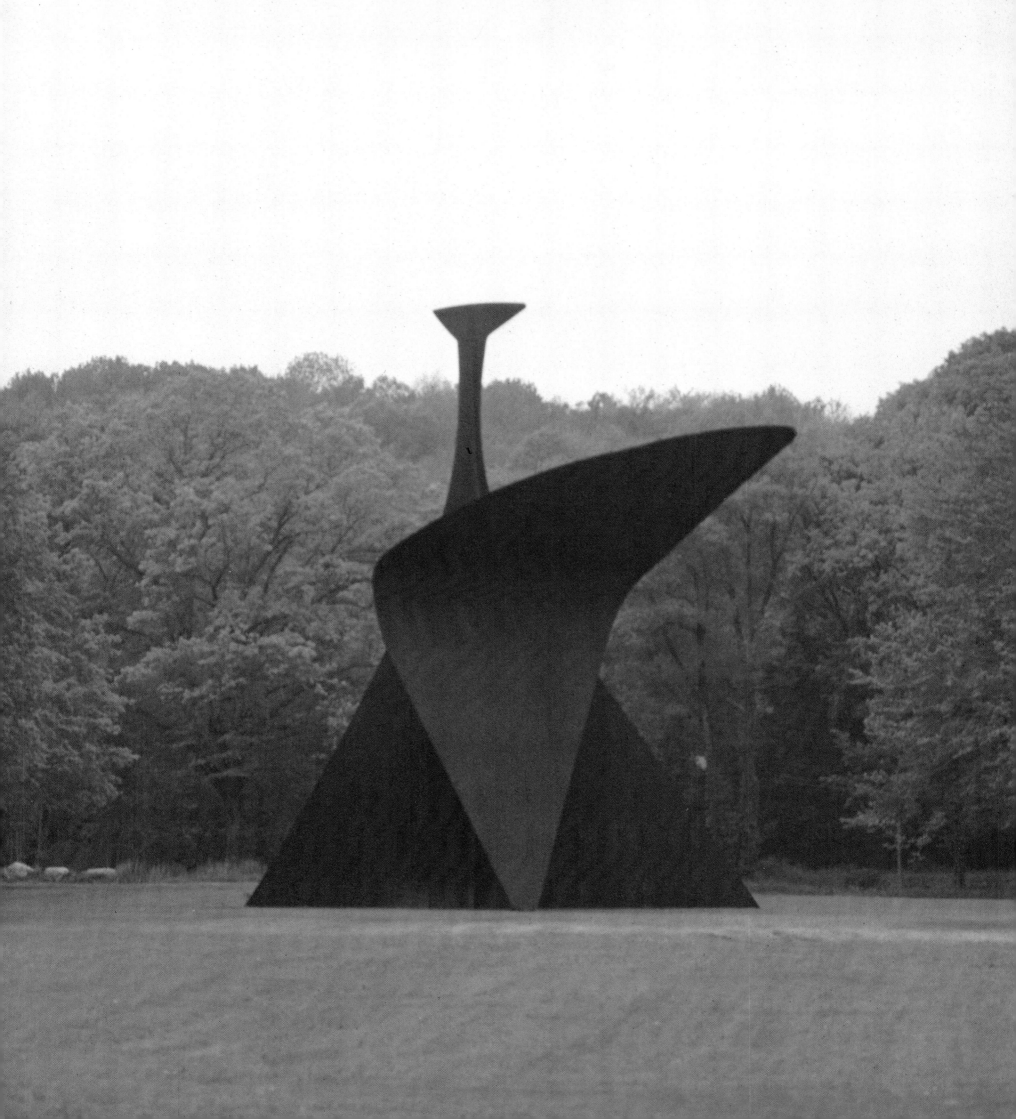

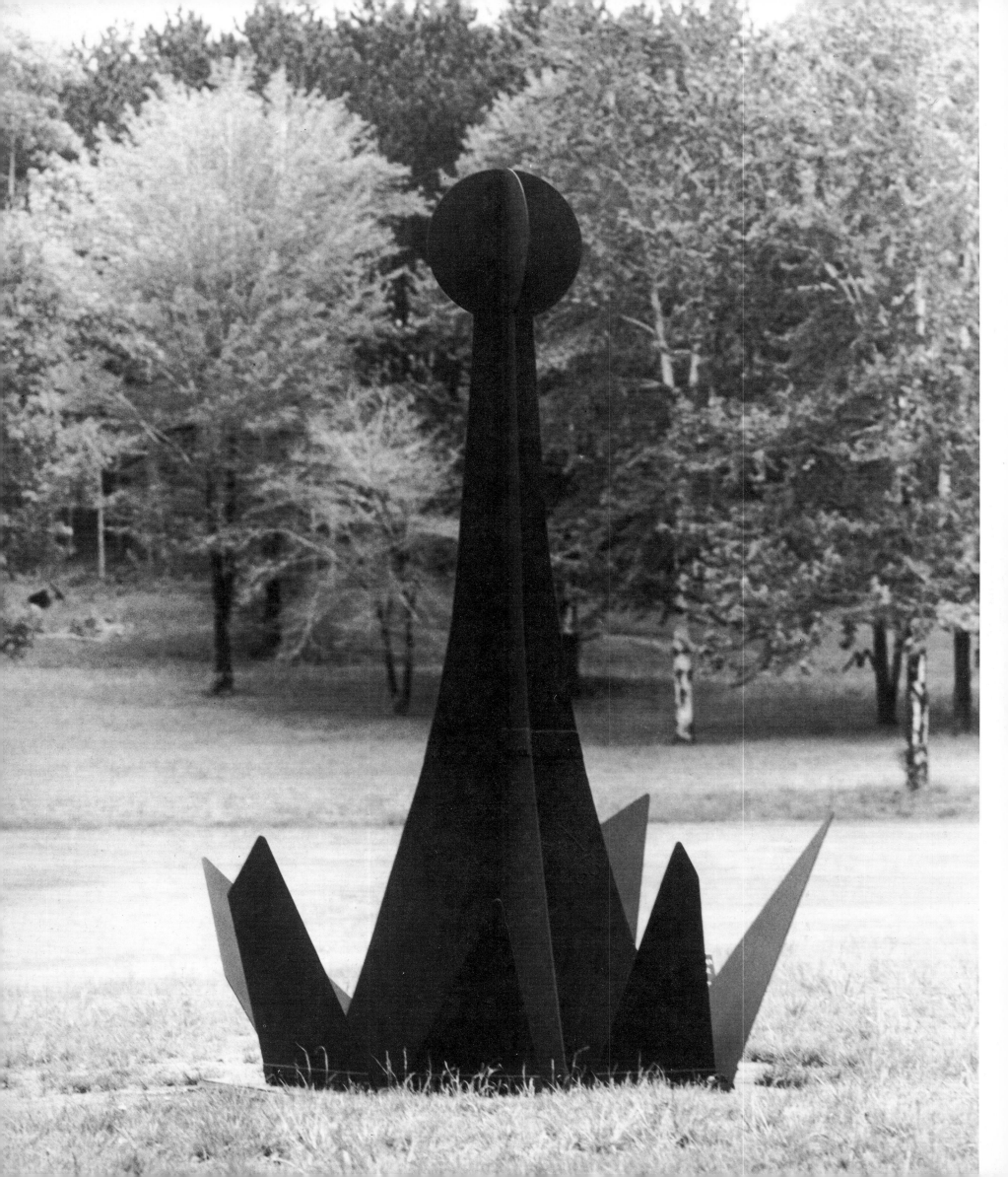

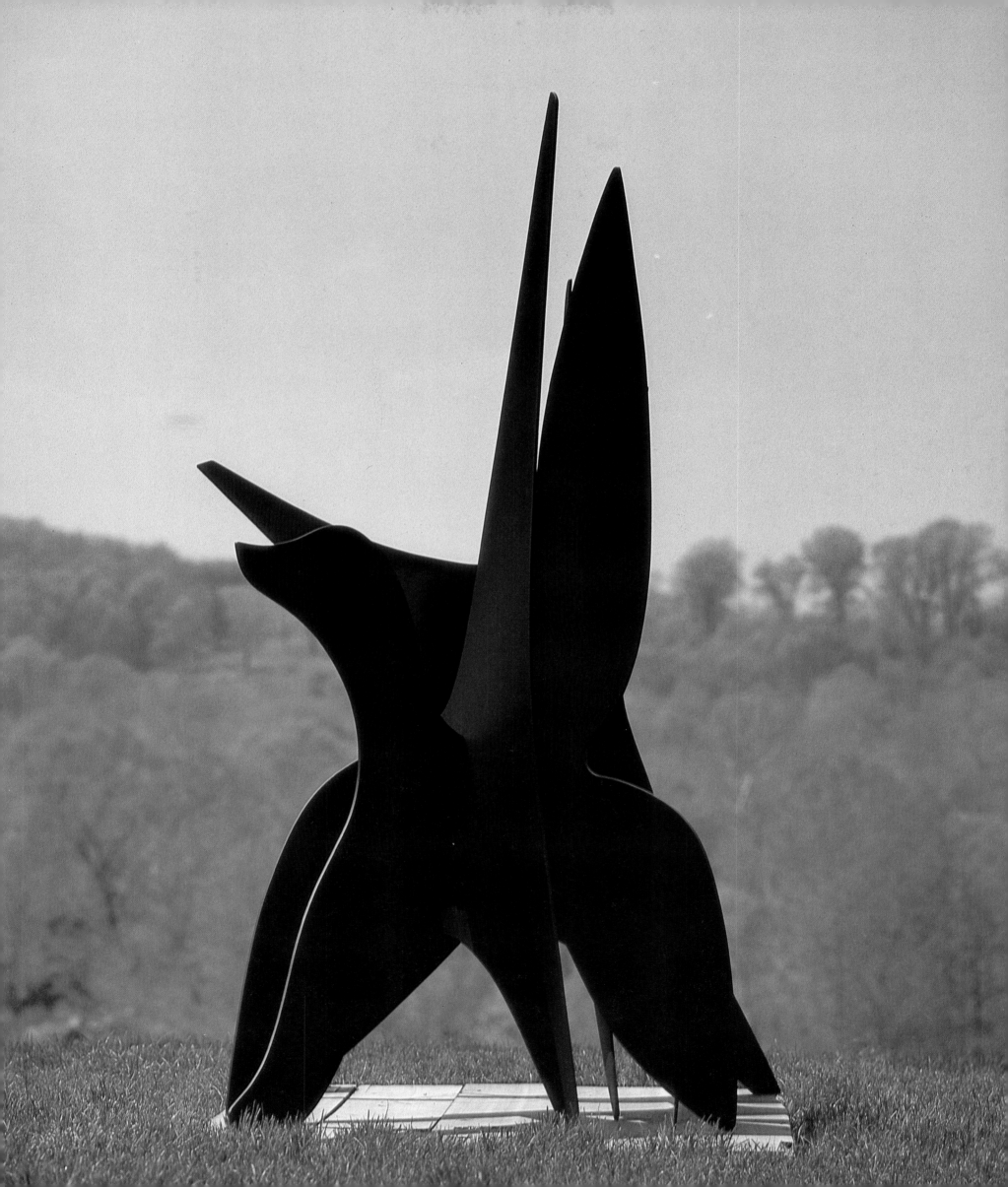

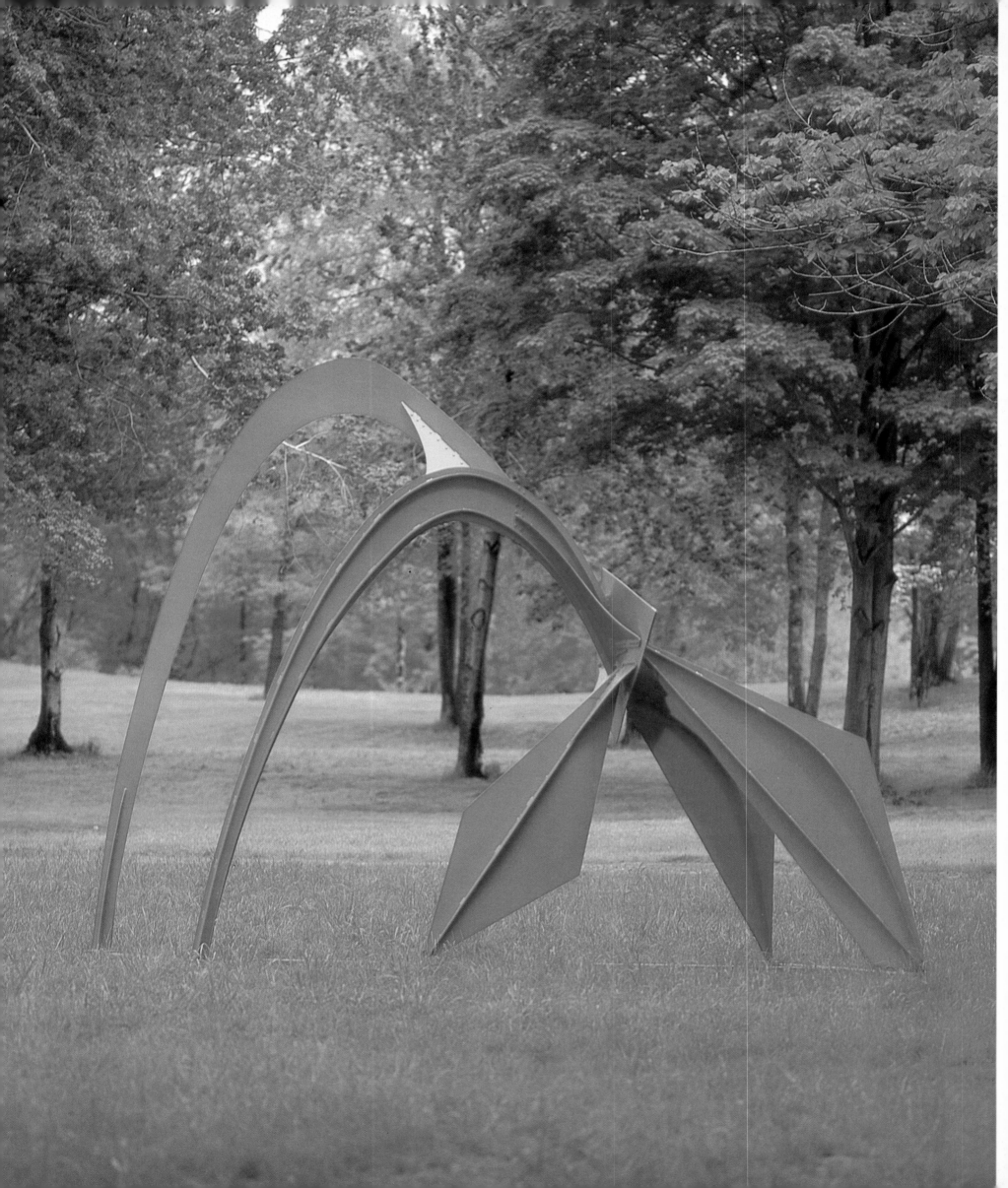

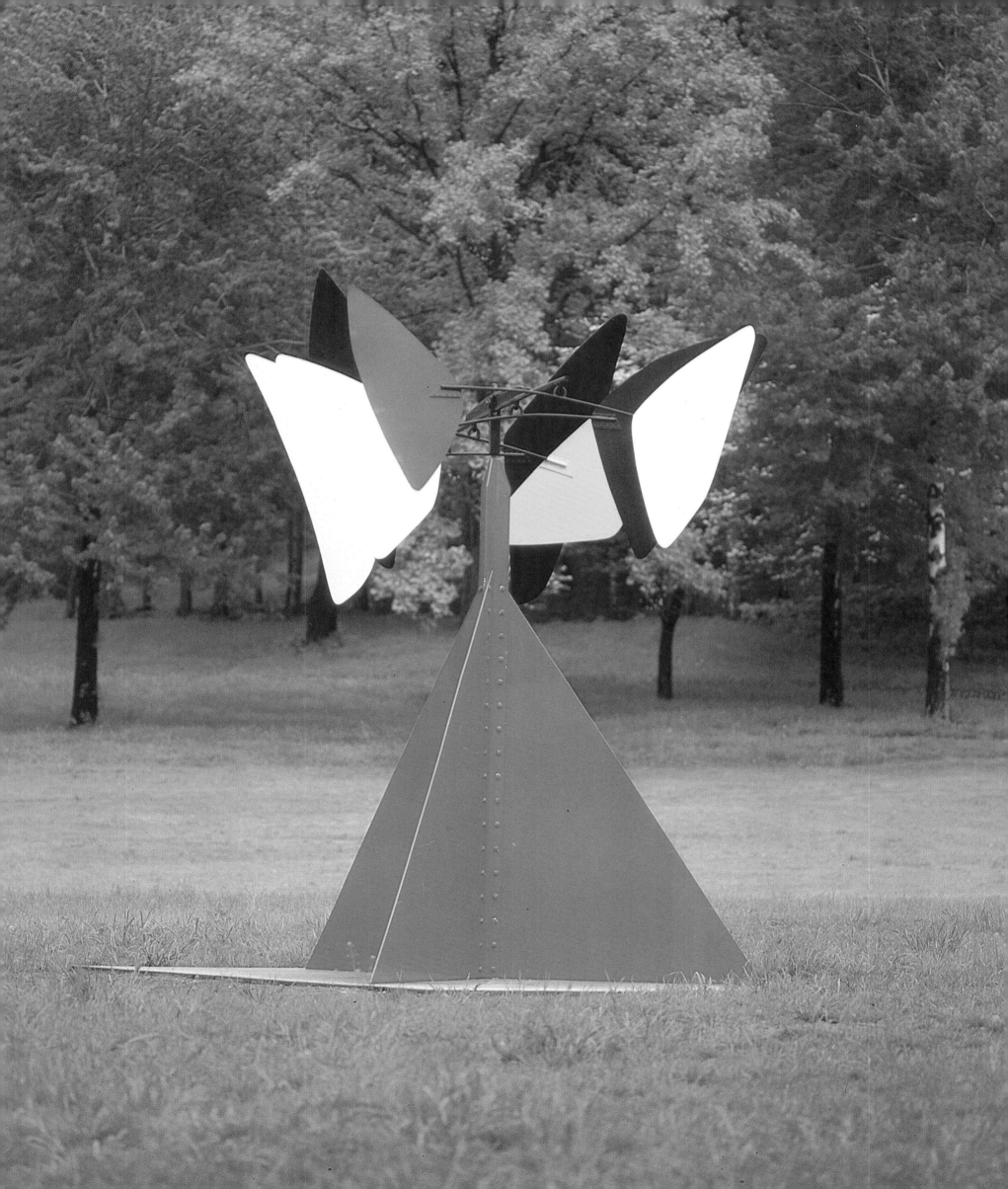

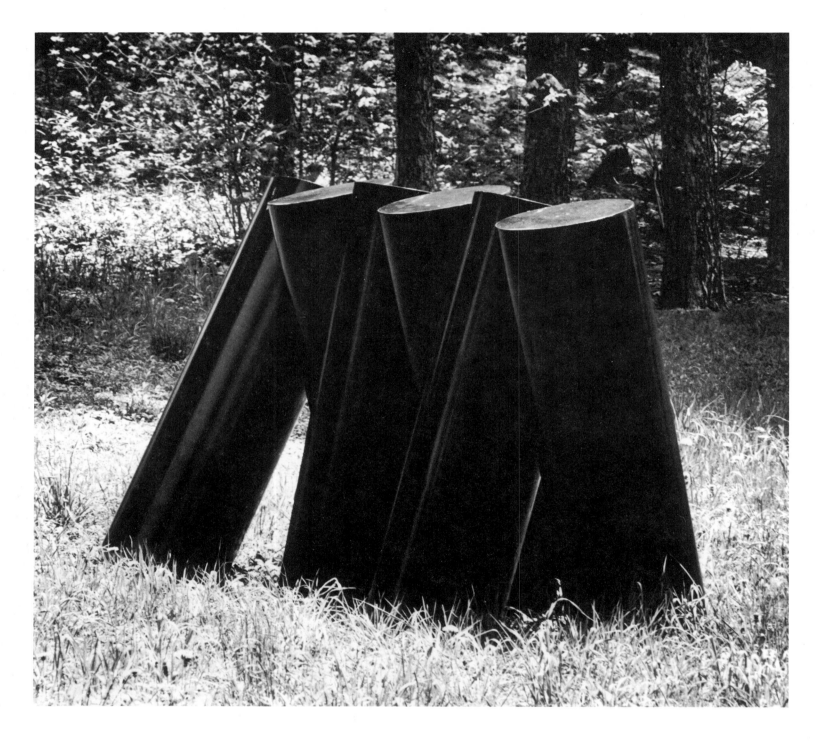

An array of tilting tubes, "Six Black Cylinders" by William Tucker (above) is a mirror image of the tree trunks in the background.

The forest is transformed into chained and bolted shapes in "Strike" by Kenneth Capps (facing page right).
Robert Grosvenor's "Untitled" extended rectangle (overleaf) provides a strong black base for a panoramic view of distant hills.

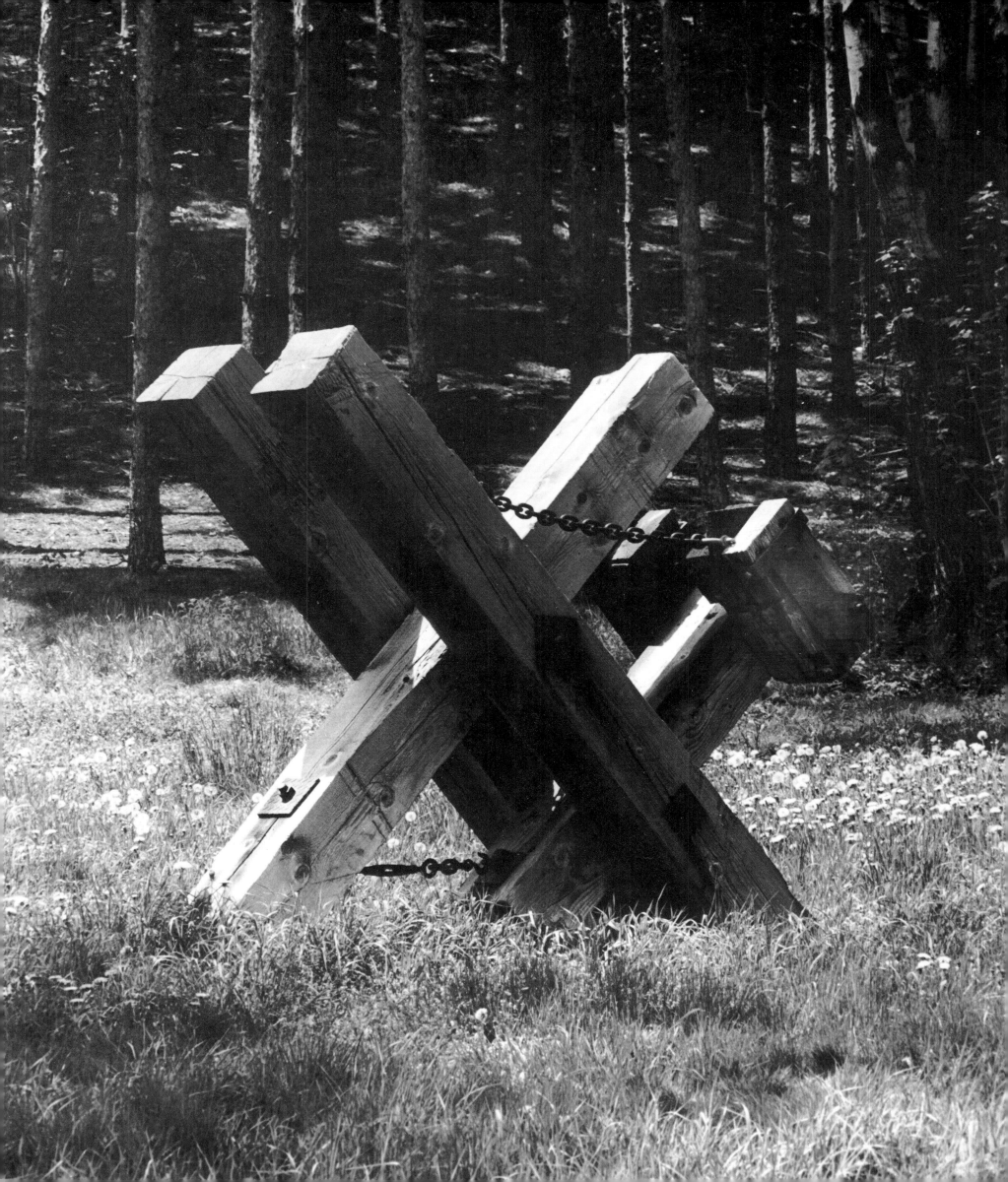

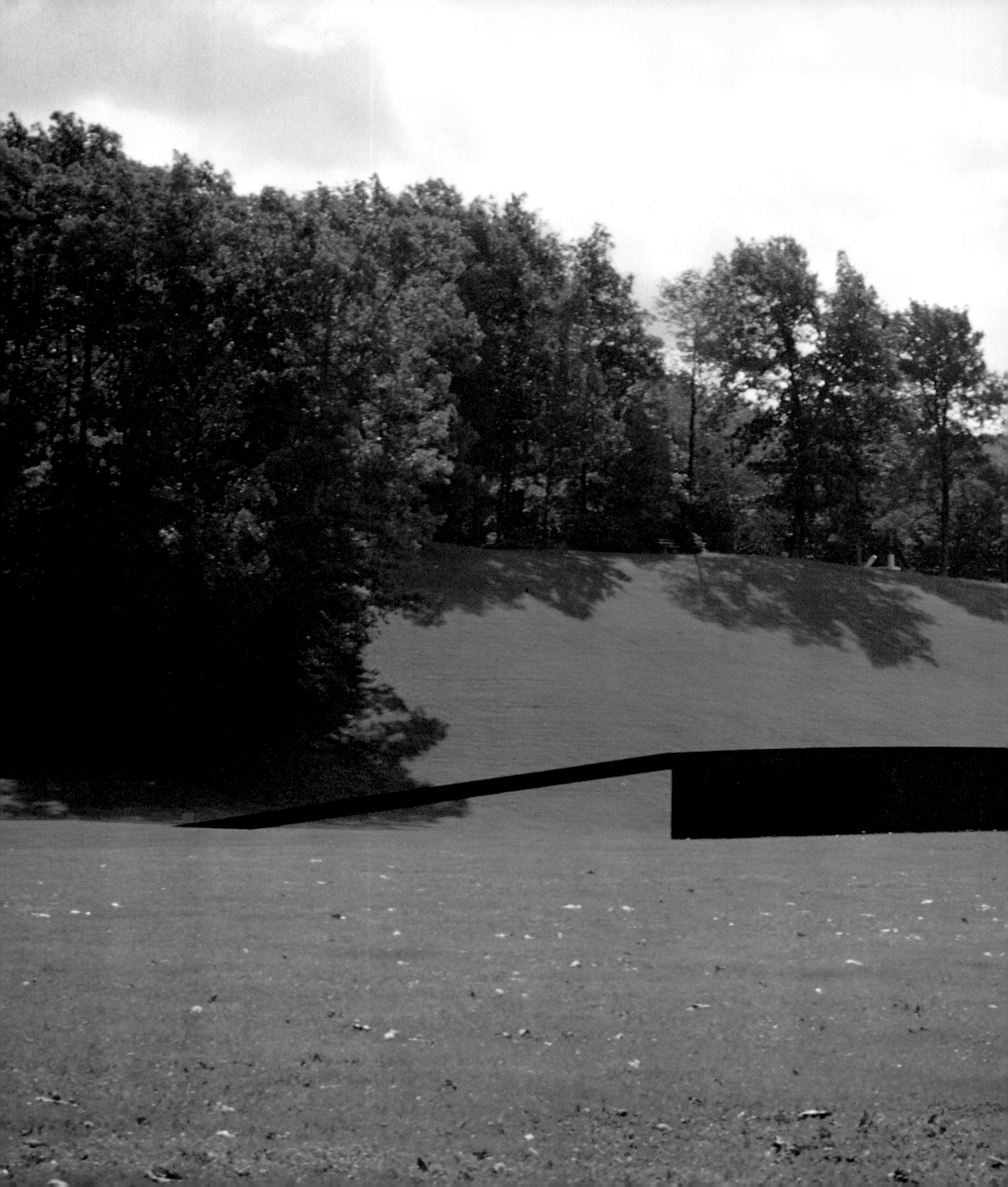

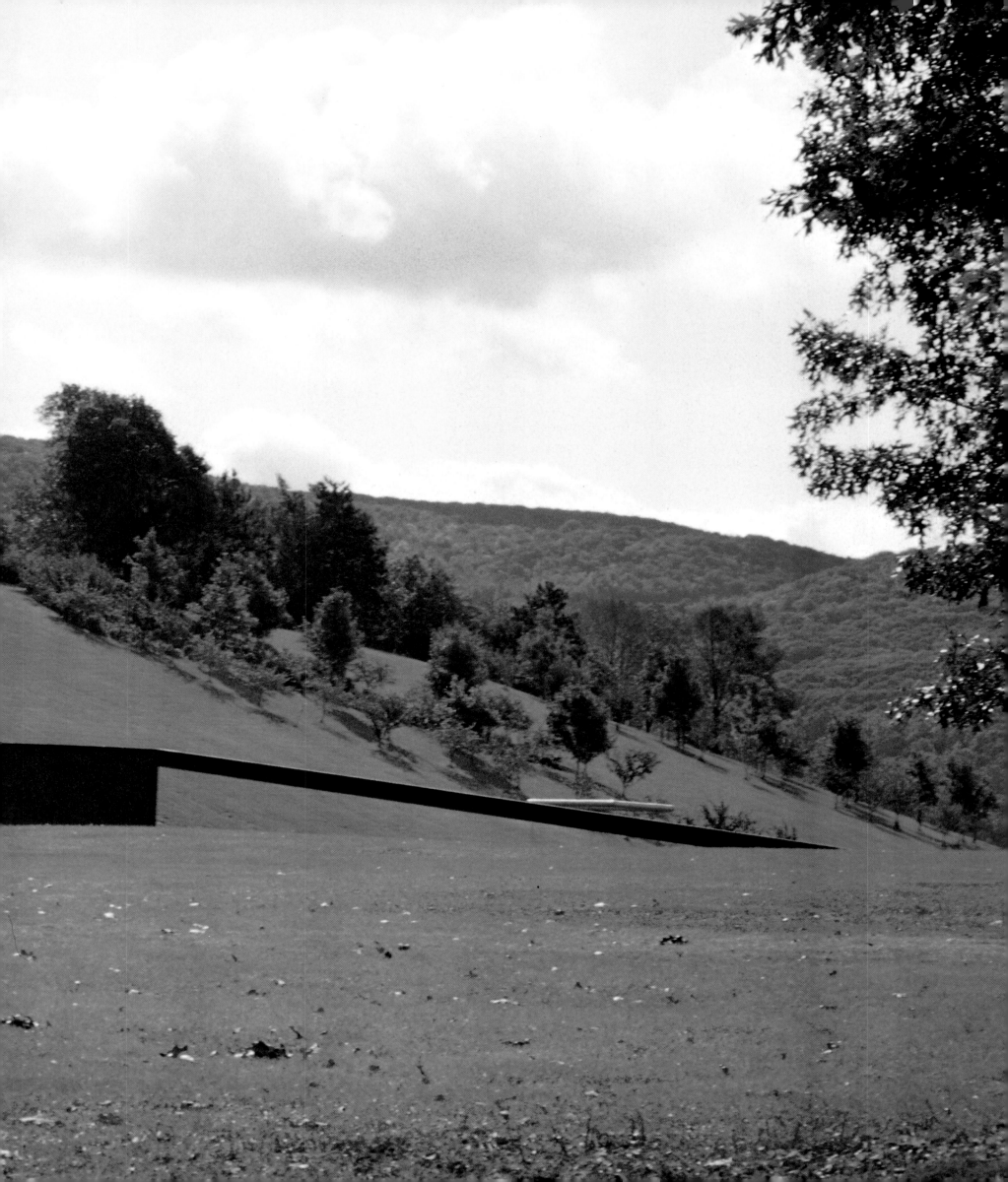

"Day Game" by David Stoltz
(below) traces its silhouetted
ribbon against the green, like
a drawing on the grass.
Roland Gebhardt's "Untitled"
geometric forms (facing
page) rise gracefully out of the
shadowed slope.

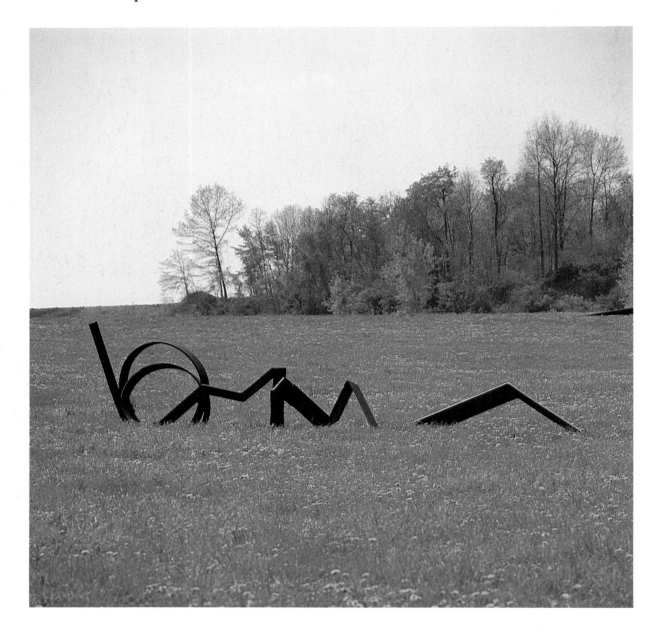

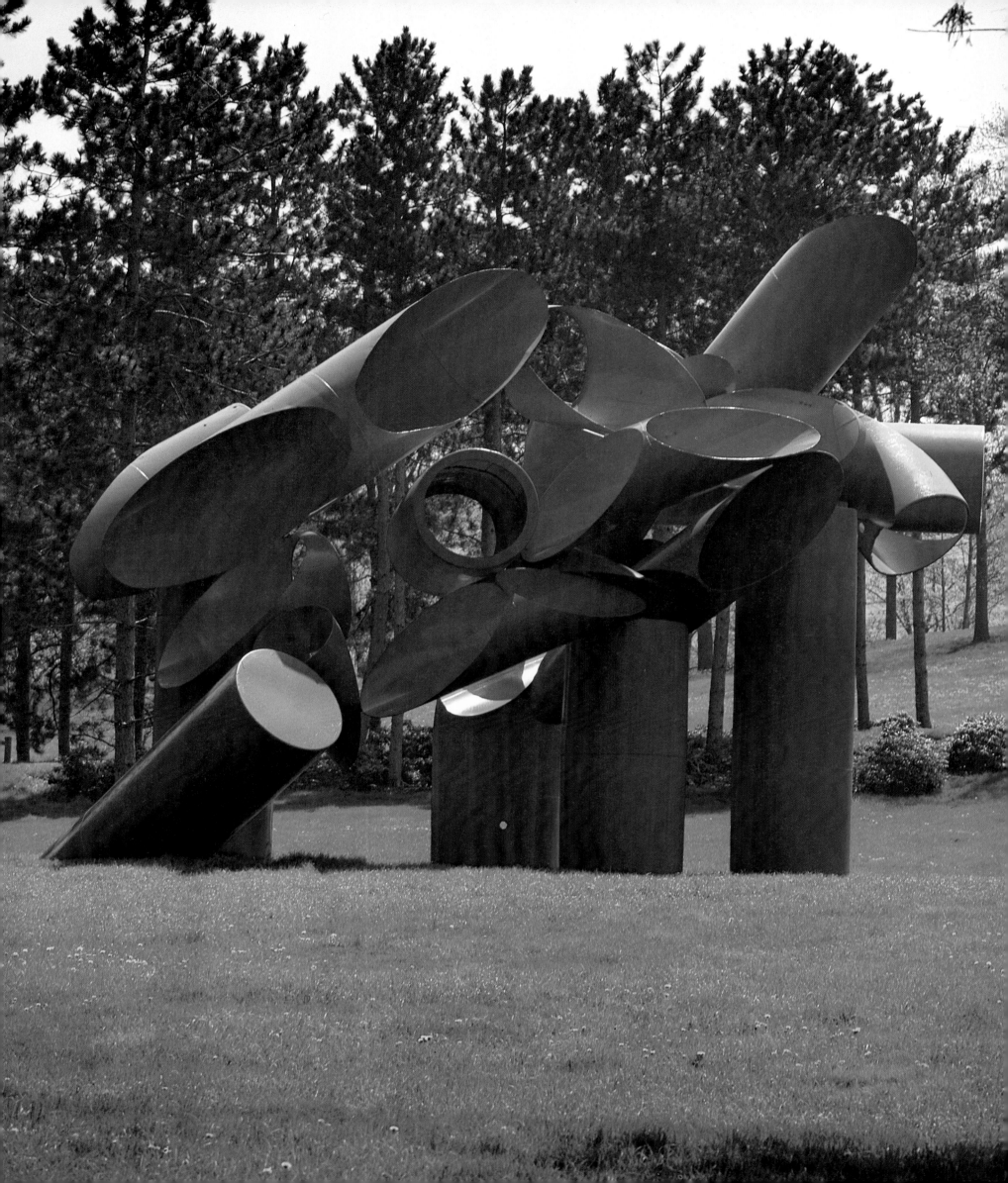

Three sculptures of contrasting designs, materials, and scale stand near each other at the foot of a hill. "Iliad" by Alexander Liberman (facing page); "Growing Forms" by Karl Pfann (right); and "Five Modular Units" by Sol LeWitt (below).

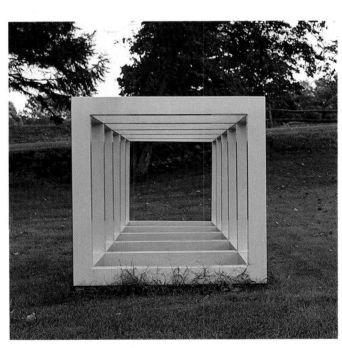

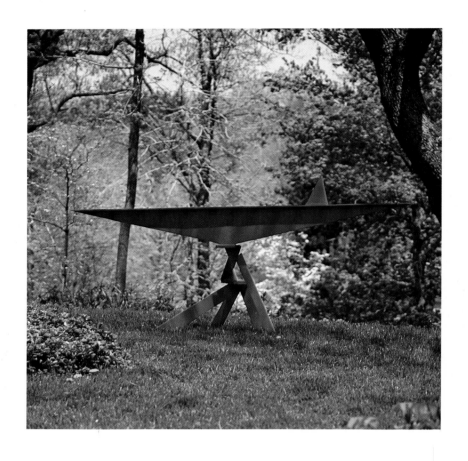

Placed appropriately in a grove of trees, "Masai" by Isaac Witkin (above) cuts across the enclosed space, while the upright forms of "Etude de Mouvement" by Sorel Etrog (upper right) and "Blue Moon" by Gilbert Hawkins (lower right) are variations of the vertical thrust of surrounding tree trunks. David Von Schlegell's "Untitled" floating squares catch the sun and sky (facing page).

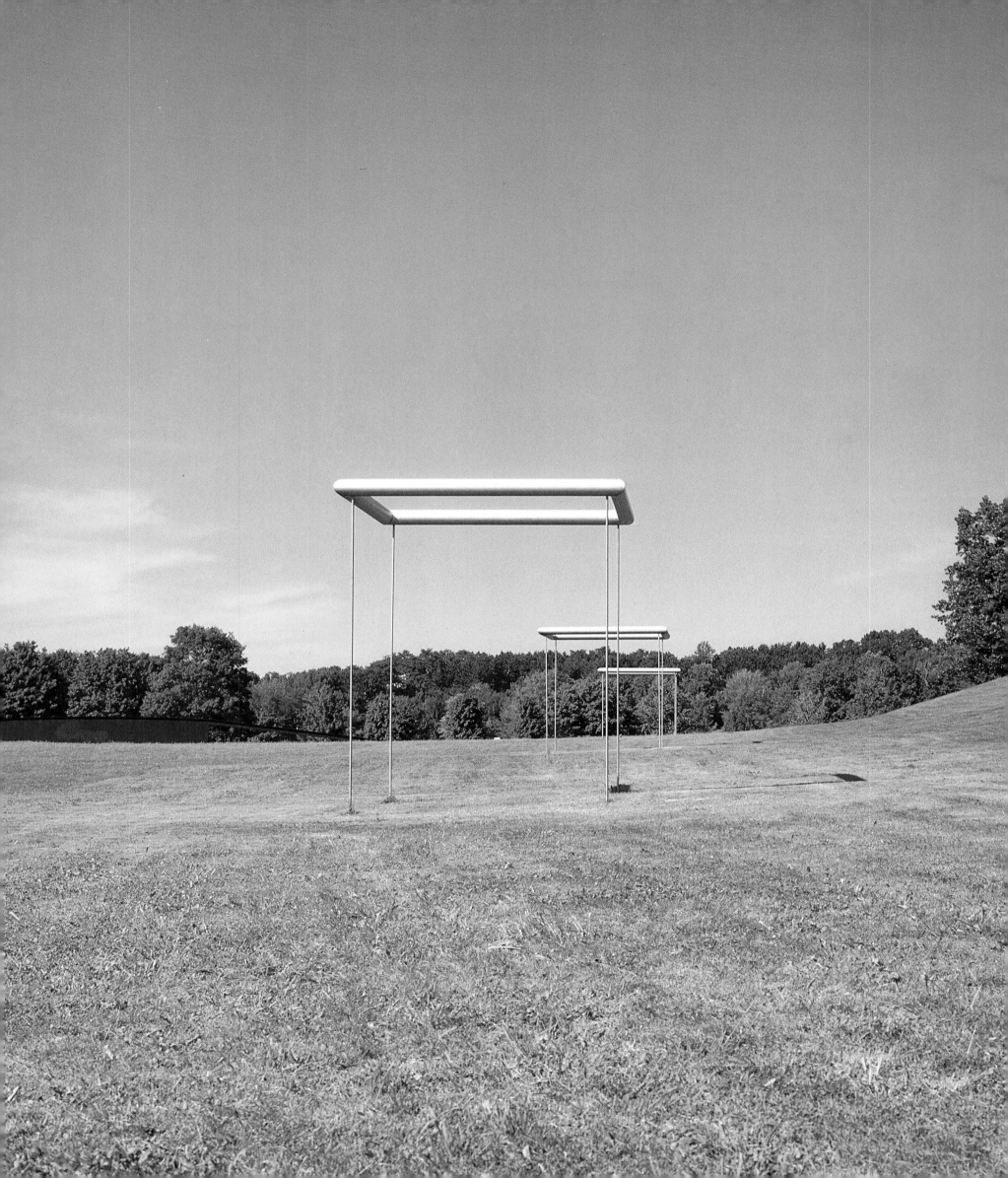

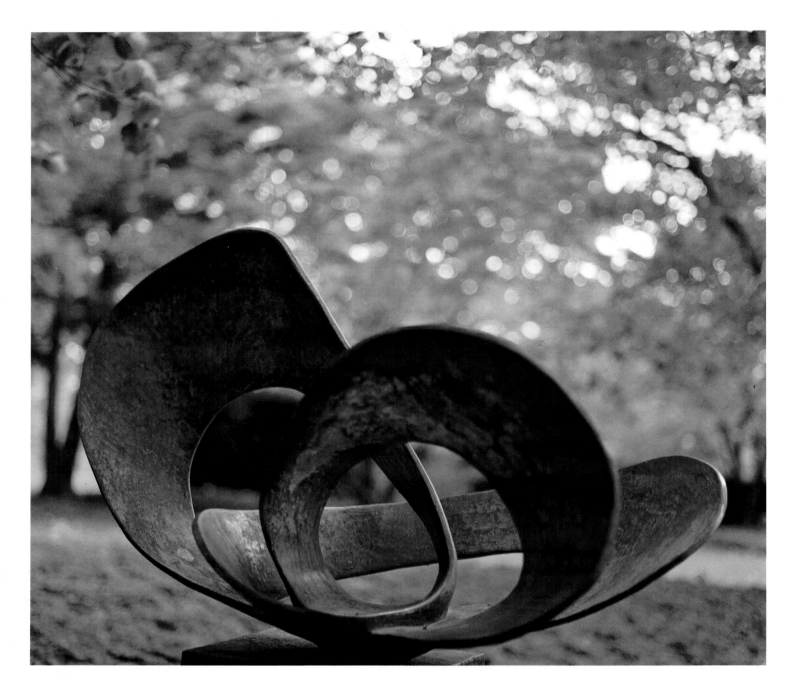

A cluster of sculptures is set among the bushes and on the lawns.
"Pavan" by Barbara Hepworth (above)
"Dying Swan" by Hans Schleeh (right)
"Helixikos Number 3" by Hans Hokanson (facing page above)
"Persephone Returns" by Kenneth Campbell (facing page lower left)
"Champion" by Joseph Konzal (facing page lower right)

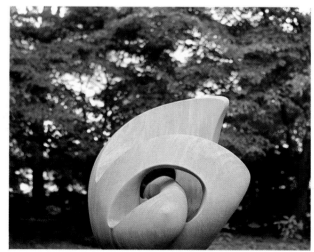

Overleaf
Jutting forms create dramatic
patterns against the sky.
"Mantis" by Forrest Myers
(p. 64)
"Large Pulcinella" by Sorel
Etrog (p. 65)
"Fayette: For Charles and
Medgar Evars" by Charles
Ginnever (pp. 66 – 67)

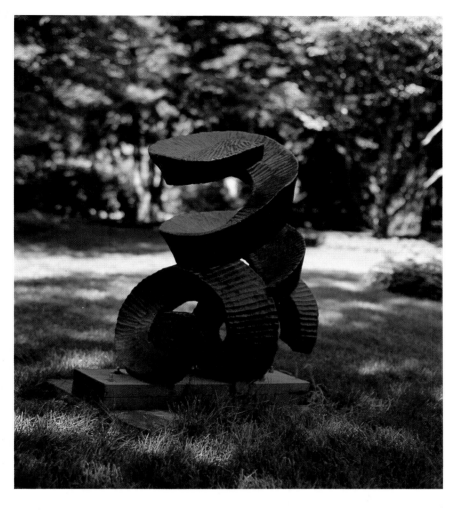

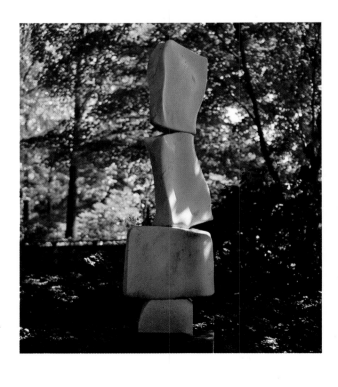

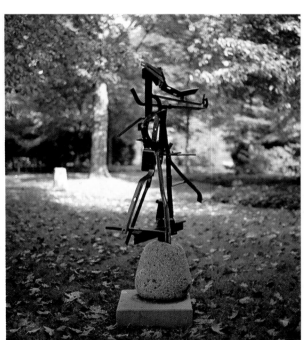

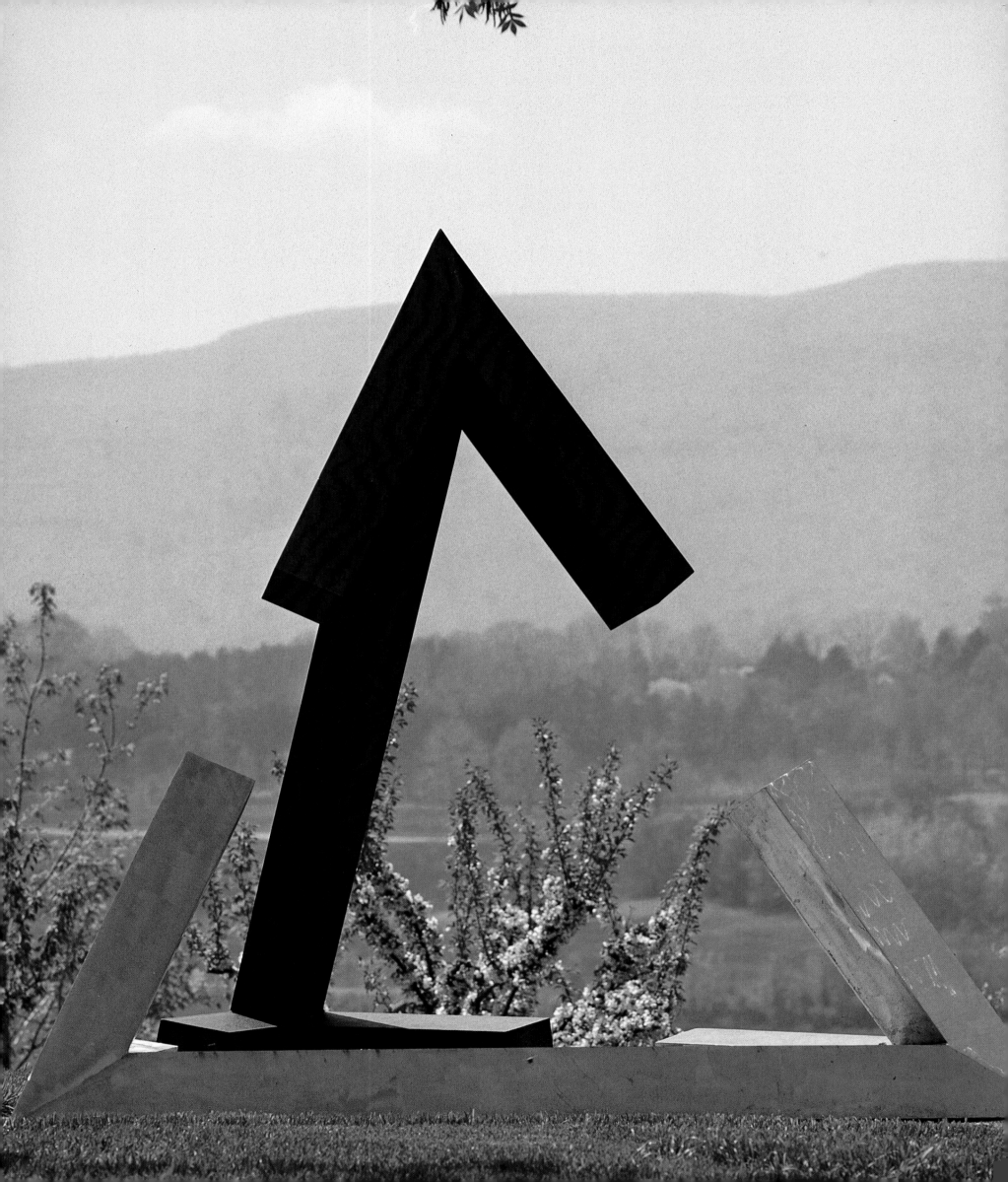

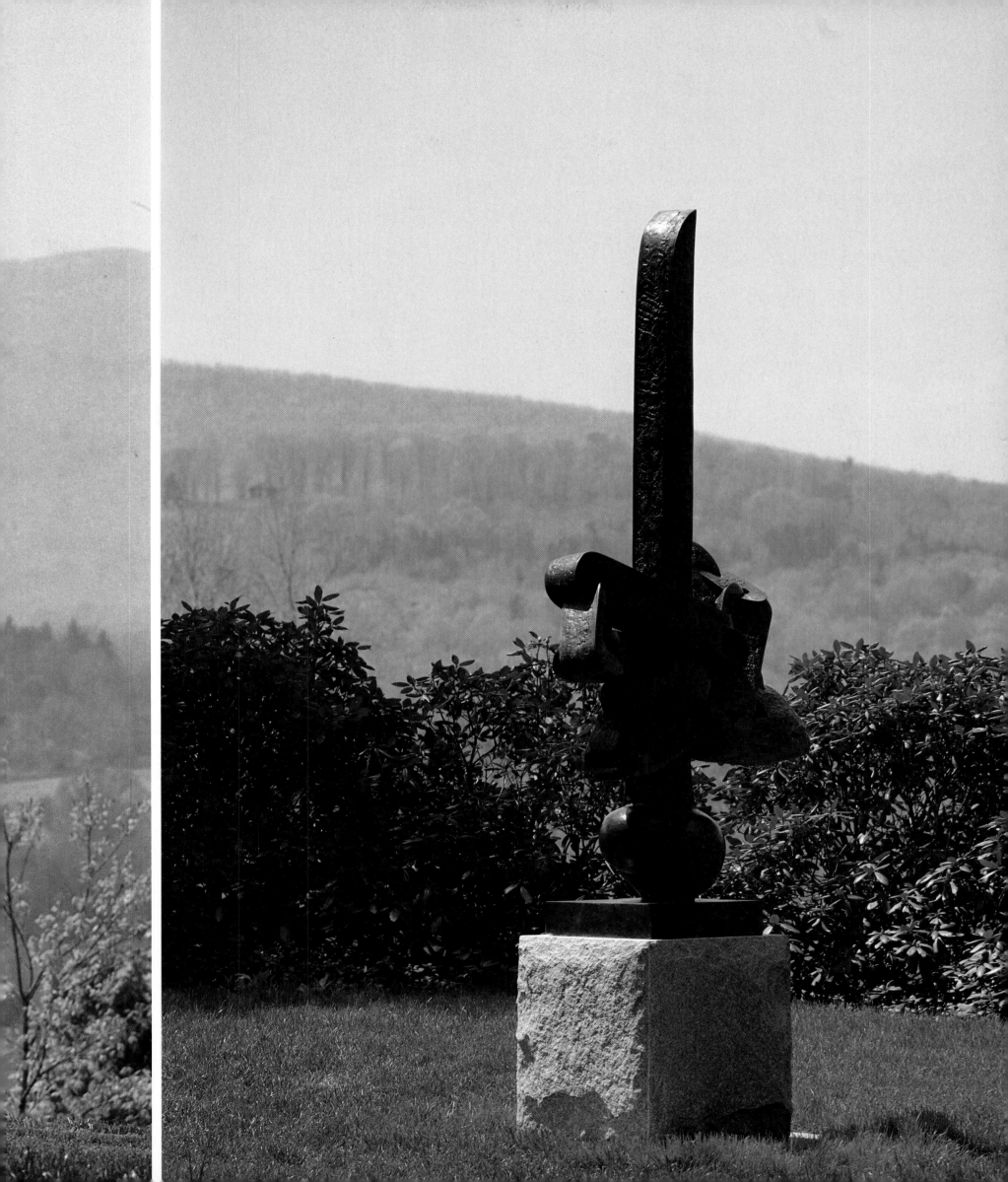

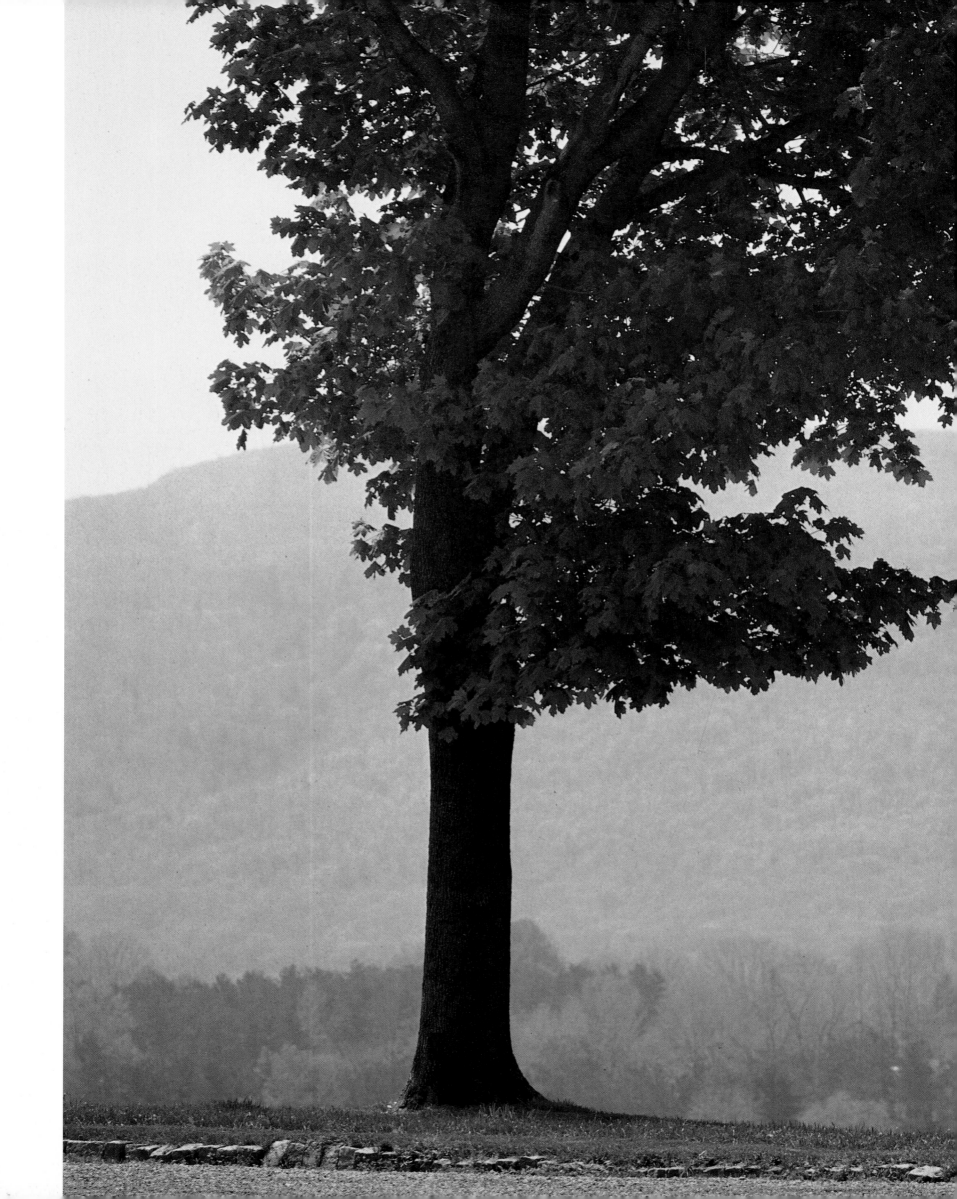

"Night Traveler" by Joel Perlman (facing page)
Reflected light on angled steel in "Seachange" by Anthony Caro (above right) and "Reel" (above).
"Dependence" by Helaine Blumenfeld (below right)

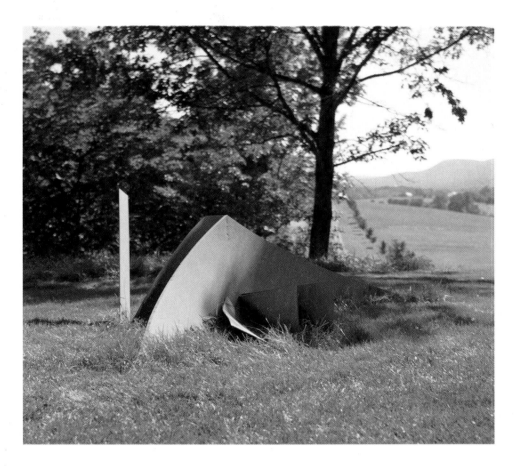

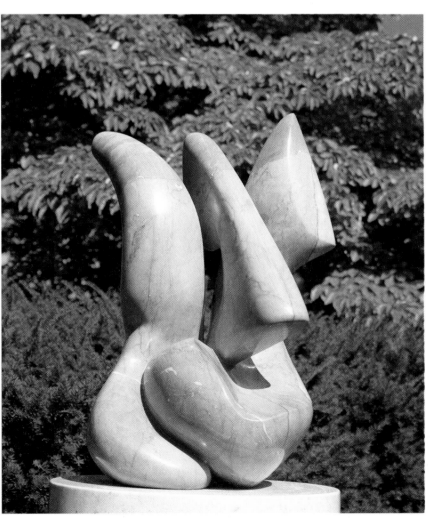

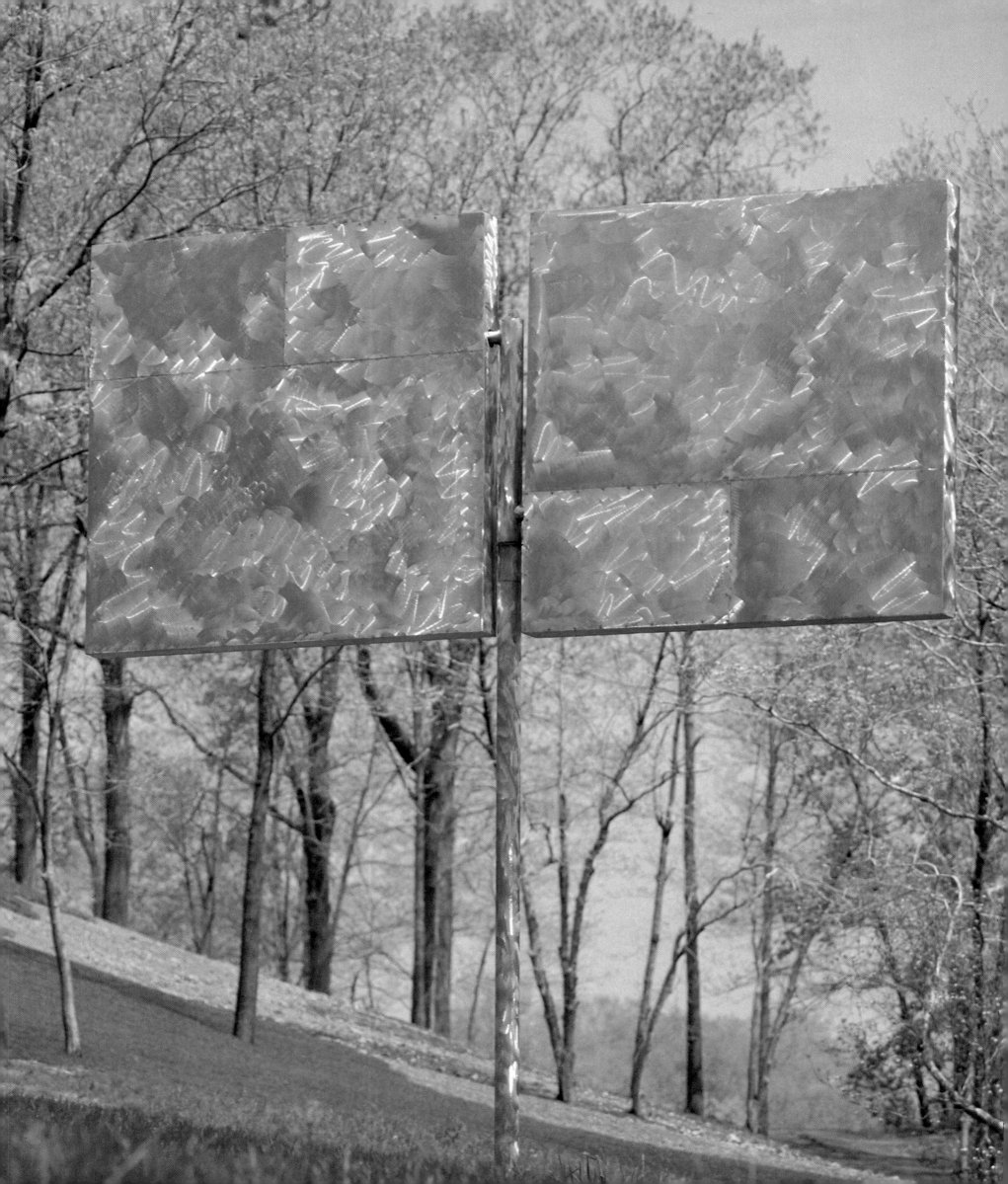

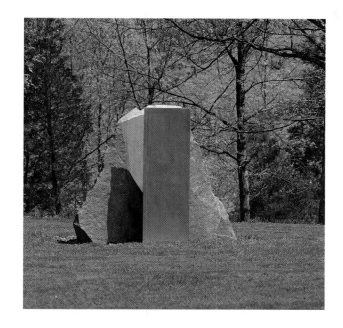

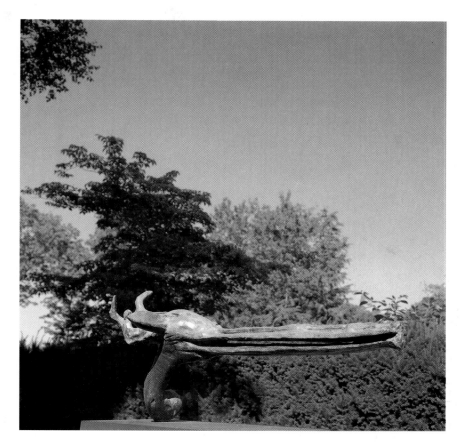

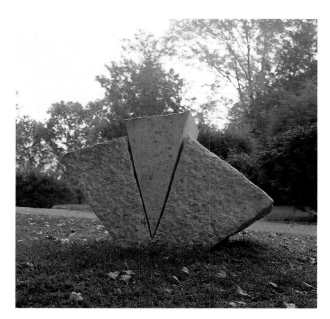

Forms flowing from the textures and natural shapes of materials fit into the landscape.
"Two Planes Vertical—Horizontal II" by George Rickey (facing page)
"Inheritor (for Jake)" by Jim Huntington (above right)
Stone and metal shaped into striking images are framed by the surrounding shrubbery.
"Genesis" by Kosso (middle left)
"Simplex" by Joseph Konzal (lower left)
"Le Bec" by Henri Etienne-Martin (above left)

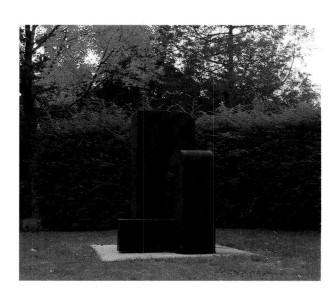

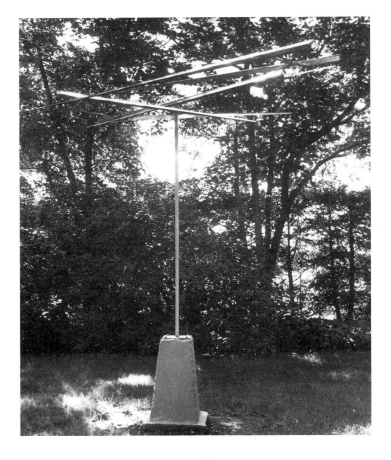

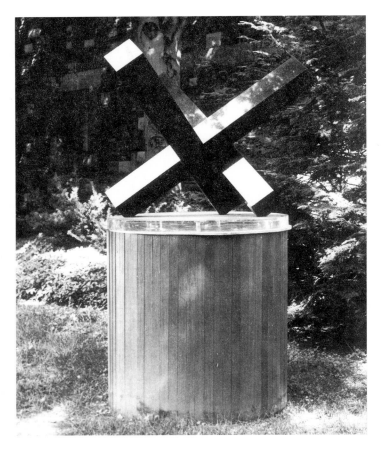

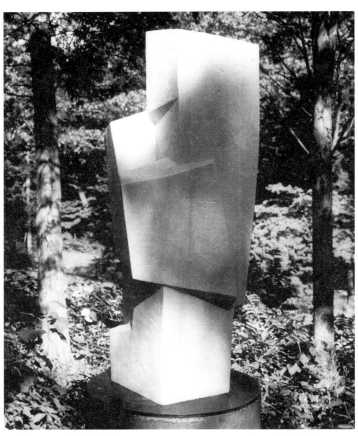

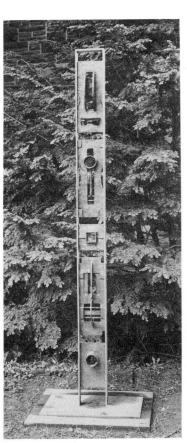

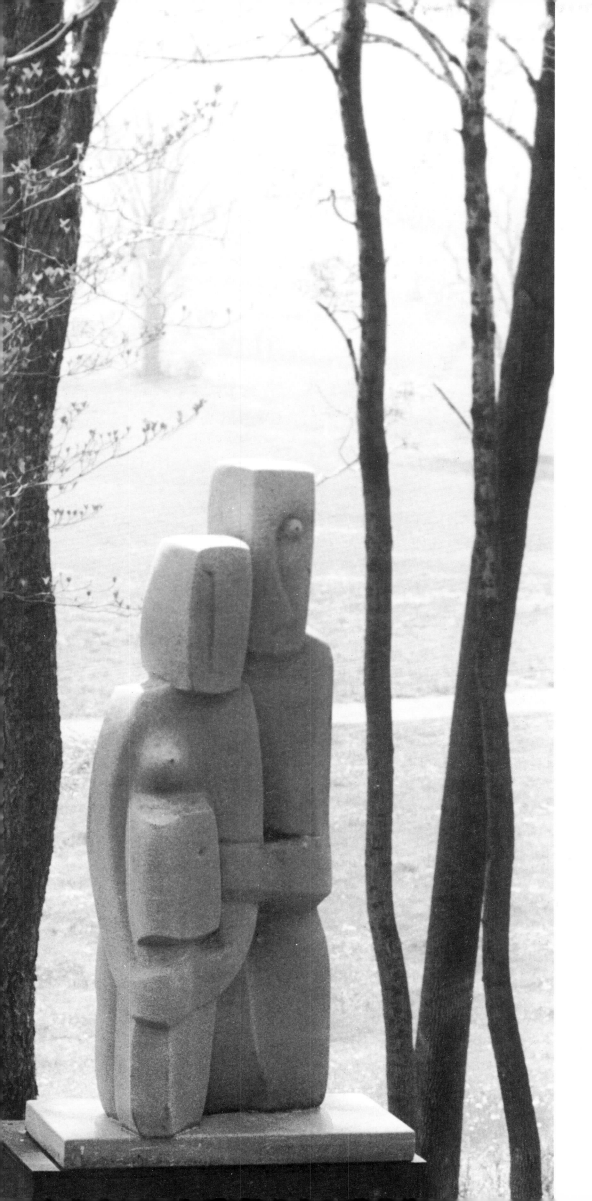

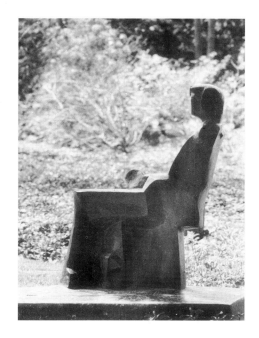

Amidst speckled shadows
from overhanging branches
are:
Facing page:
"Six Lines in a T" by George
Rickey (upper left)
"Unit of Three Elements" by
Max Bill (upper right)
"Untitled" by Josef Pillhofer
(lower left)
"Cenotaph IV" by Dorothy
Dehner (lower right)
"Uomo Seduto" by Mario
Negri (above)
"The Family" by Hans Schleeh
(left)

See-through negative spaces look out into the far reaches of an open field, "Gox No. 4" by Ernest Trova.

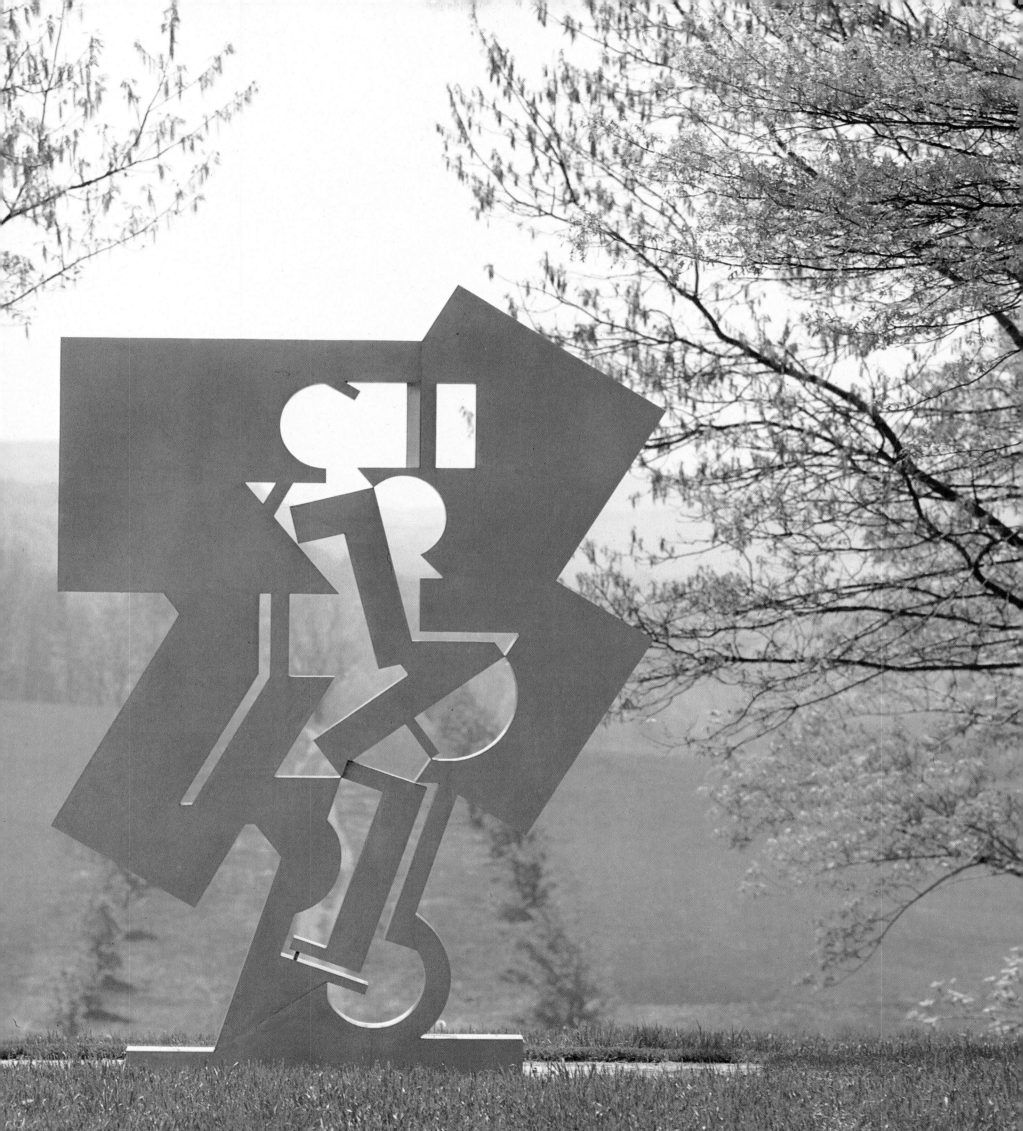

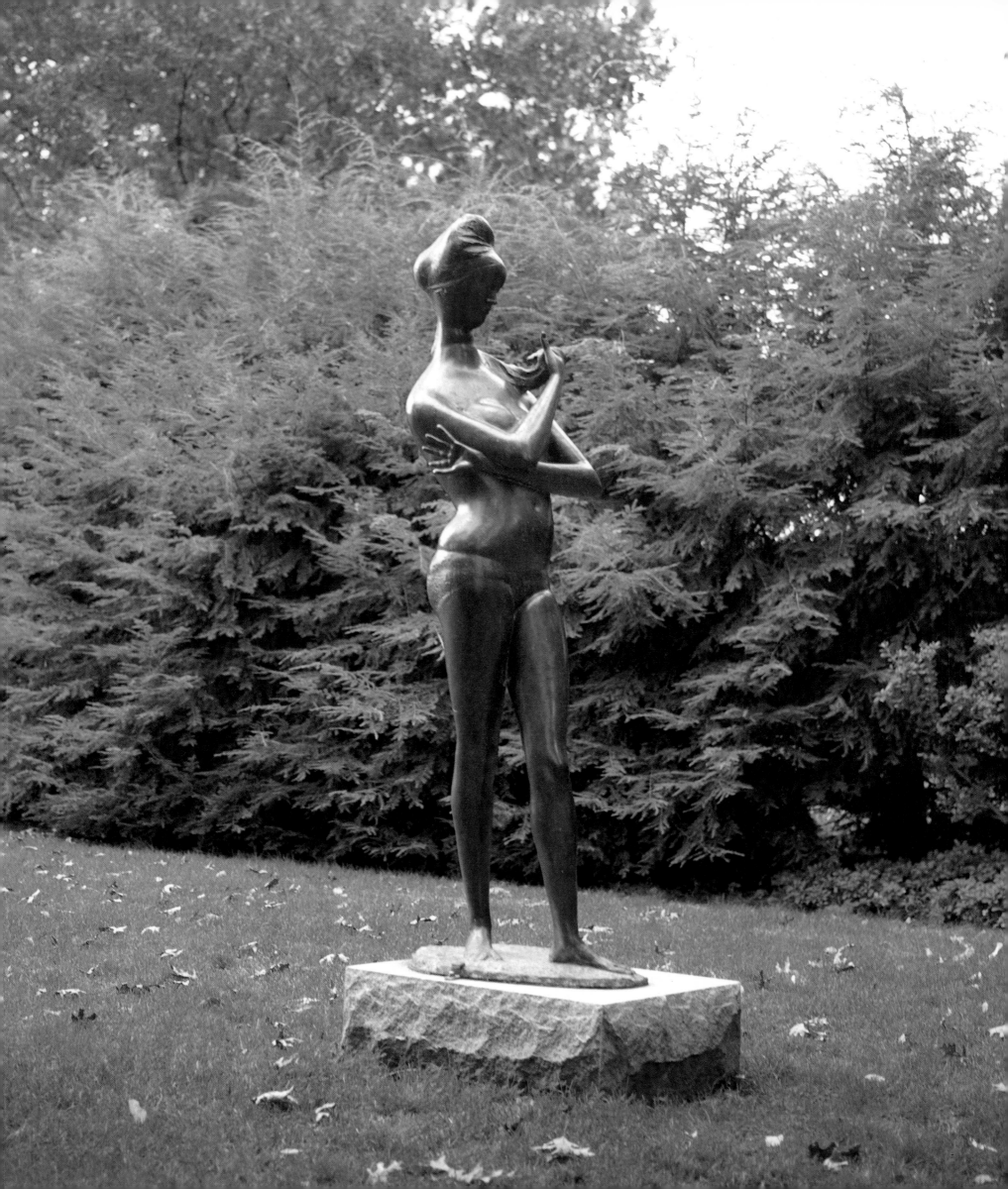

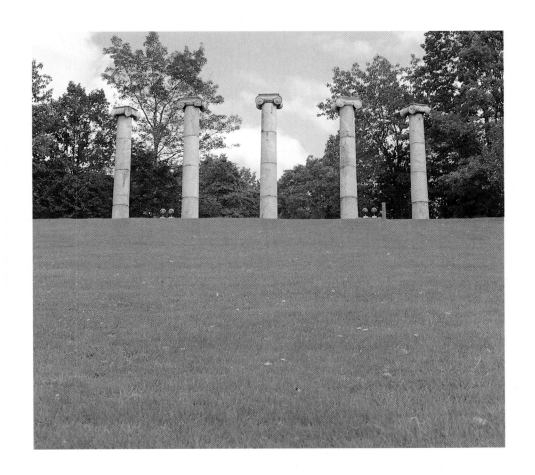

"Ionic Columns" stand on a hill, vestiges of a neo-classical era from Danskammer, the granite Edward Armstrong mansion which once stood north of Newburgh, N.Y. on the Hudson River.

Emilio Greco's "The Tall Bather I" (facing page) stands proudly with her back against the sun.

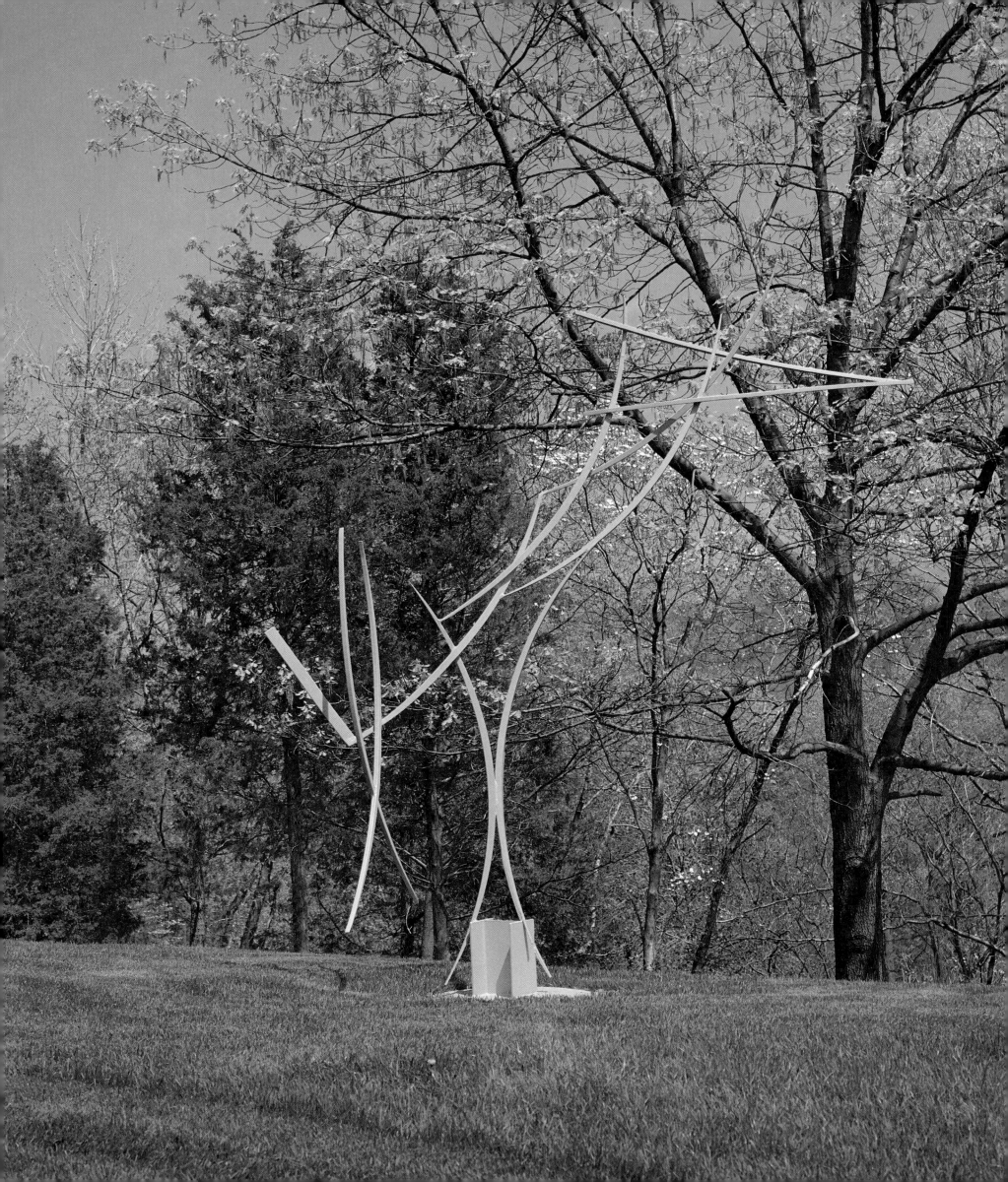

A garden of David Smith sculptures, each with its uniquely inventive play of forms, some pure abstractions, others humanoid, display his remarkable imagination and versatility. Configurations of extraordinary elegance are created out of a variety of commonplace objects and implements. These are sculptures for all seasons, as can be seen in their interplay with the forms and colors of spring and fall. Included in the collection are: "Study in Arcs" (page 78), "Portrait of a Lady Painter" (page 80), "Three Ovals Soar" (page 81), "Personage of May" (page 82), "Voltron XX" (page 83), "Becca" (page 84), "Sitting Printer" (page 85), "XI Books III Apples" (pages 86 – 87).

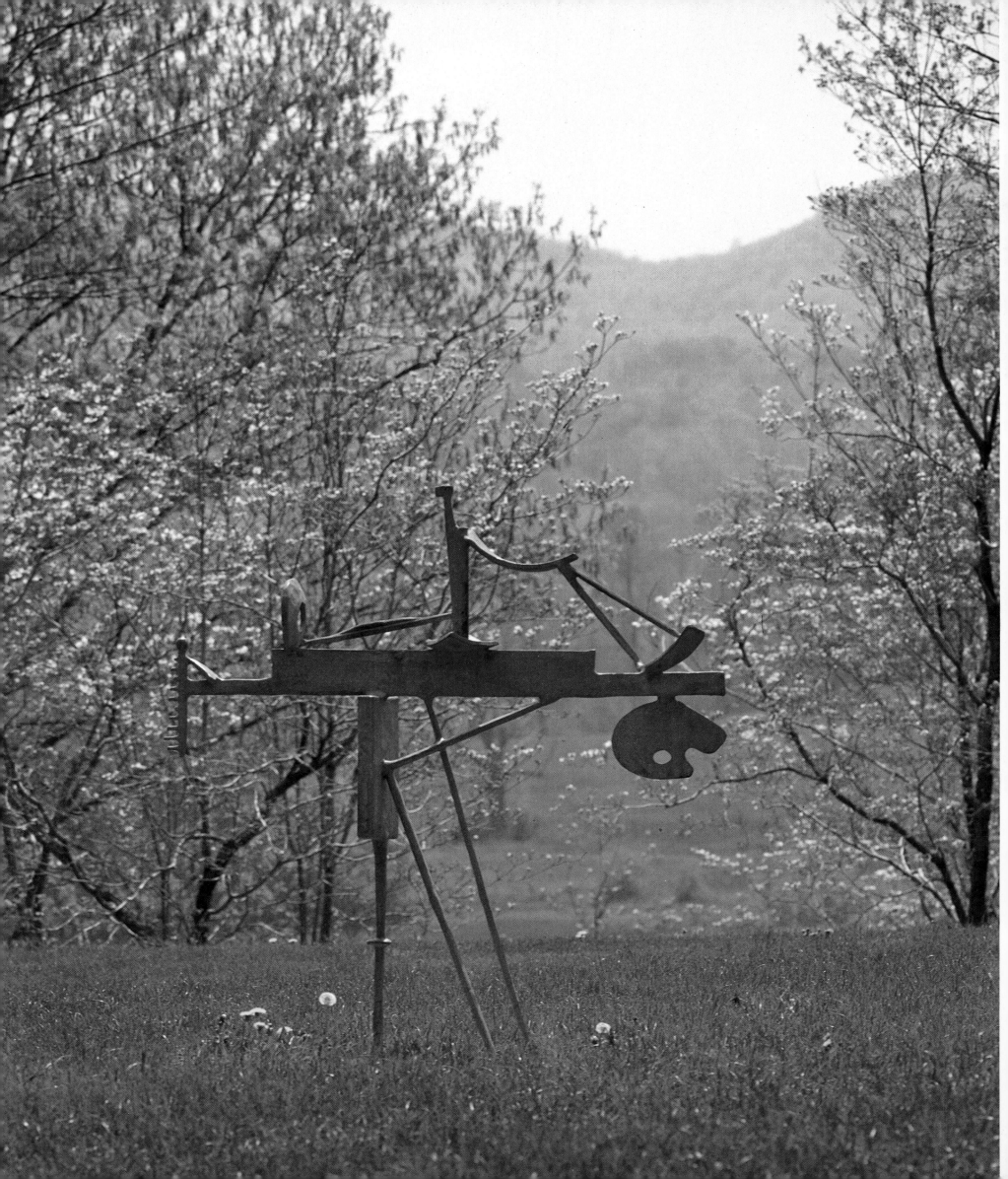

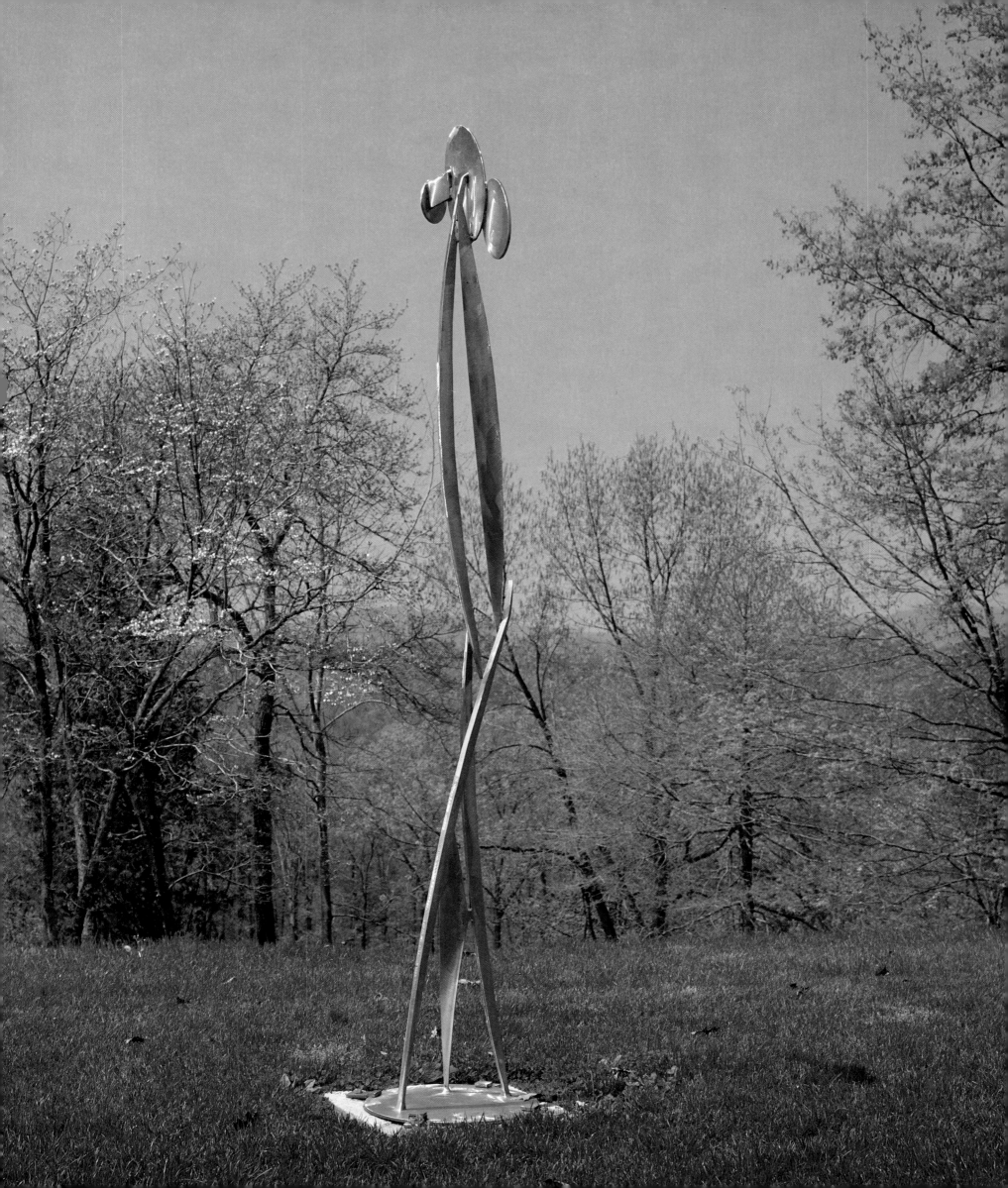

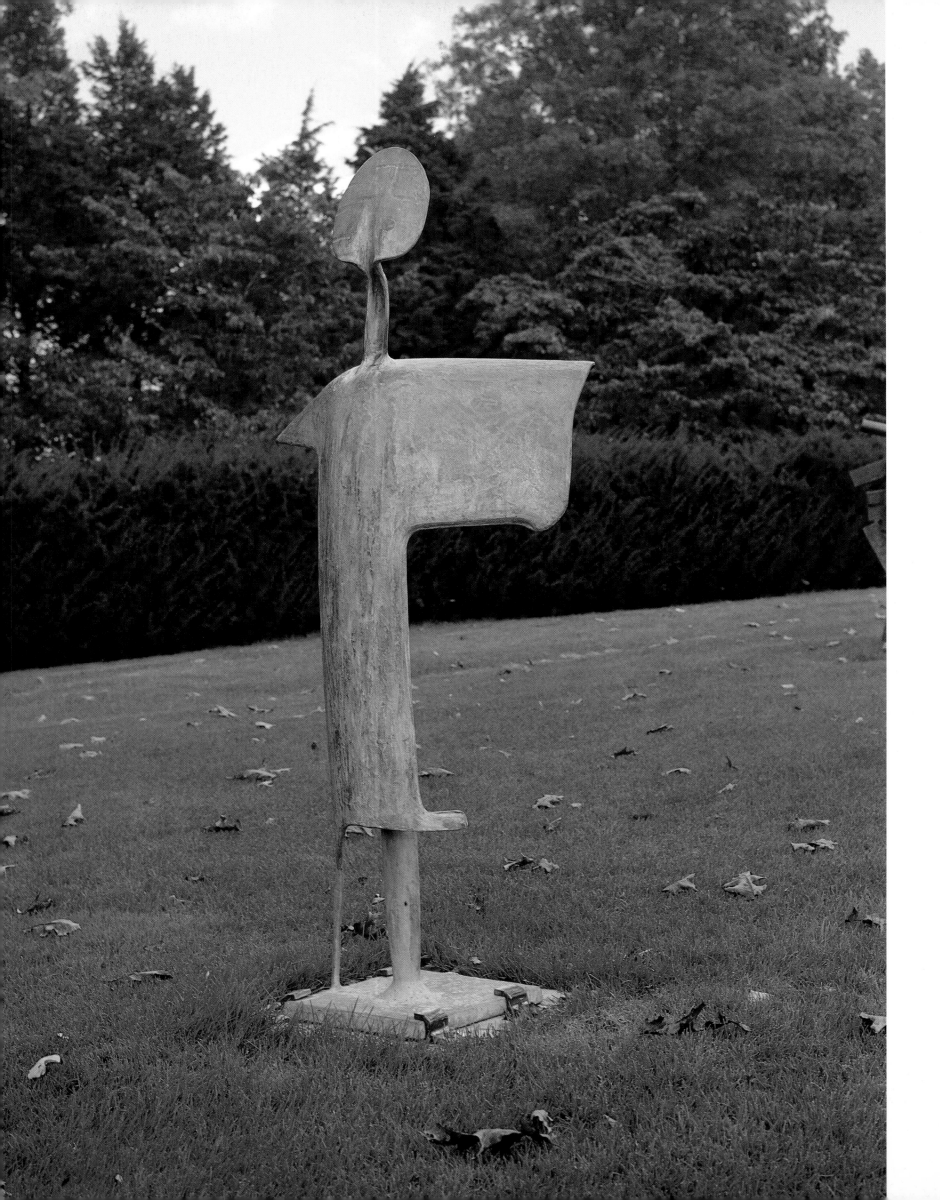

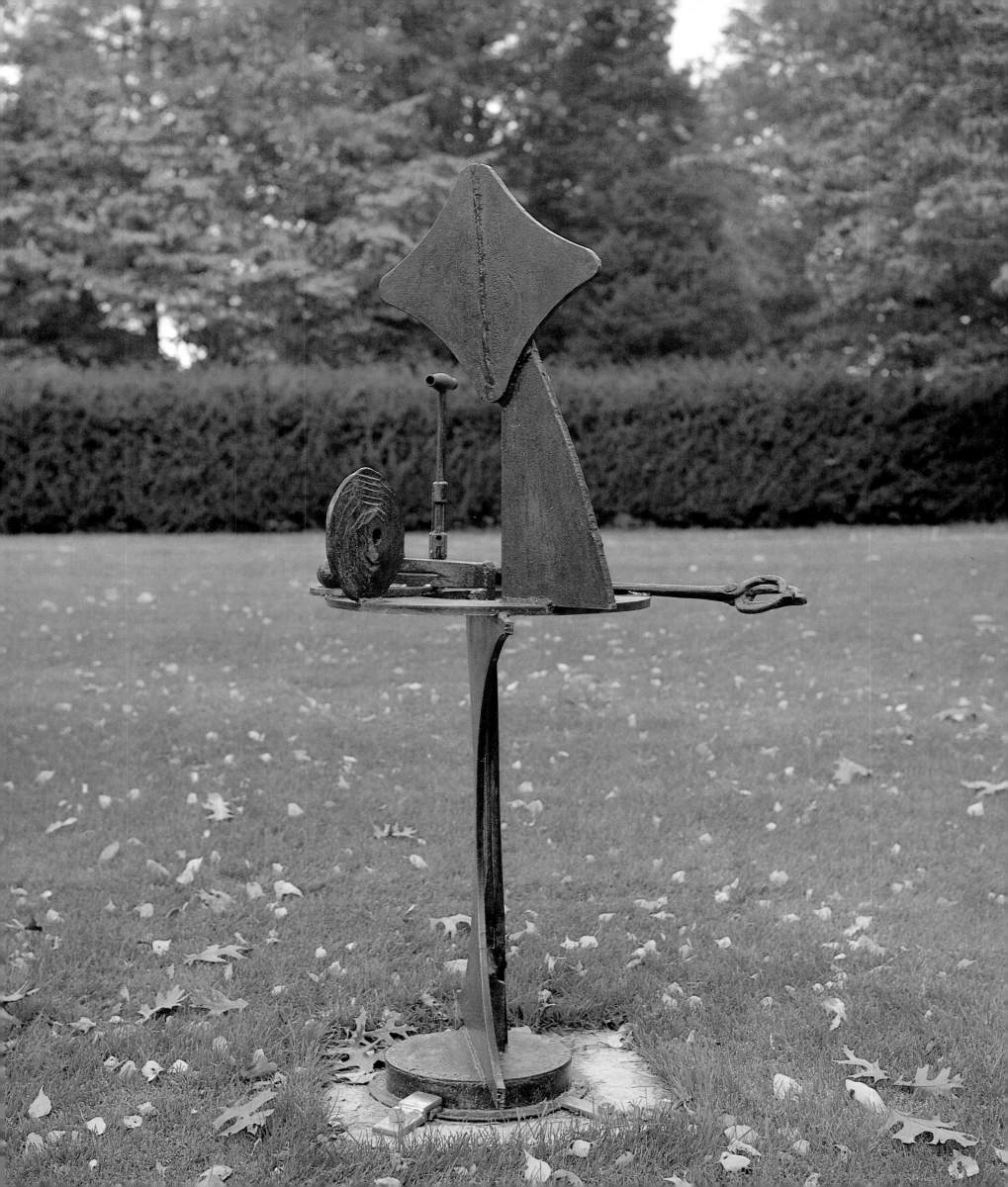

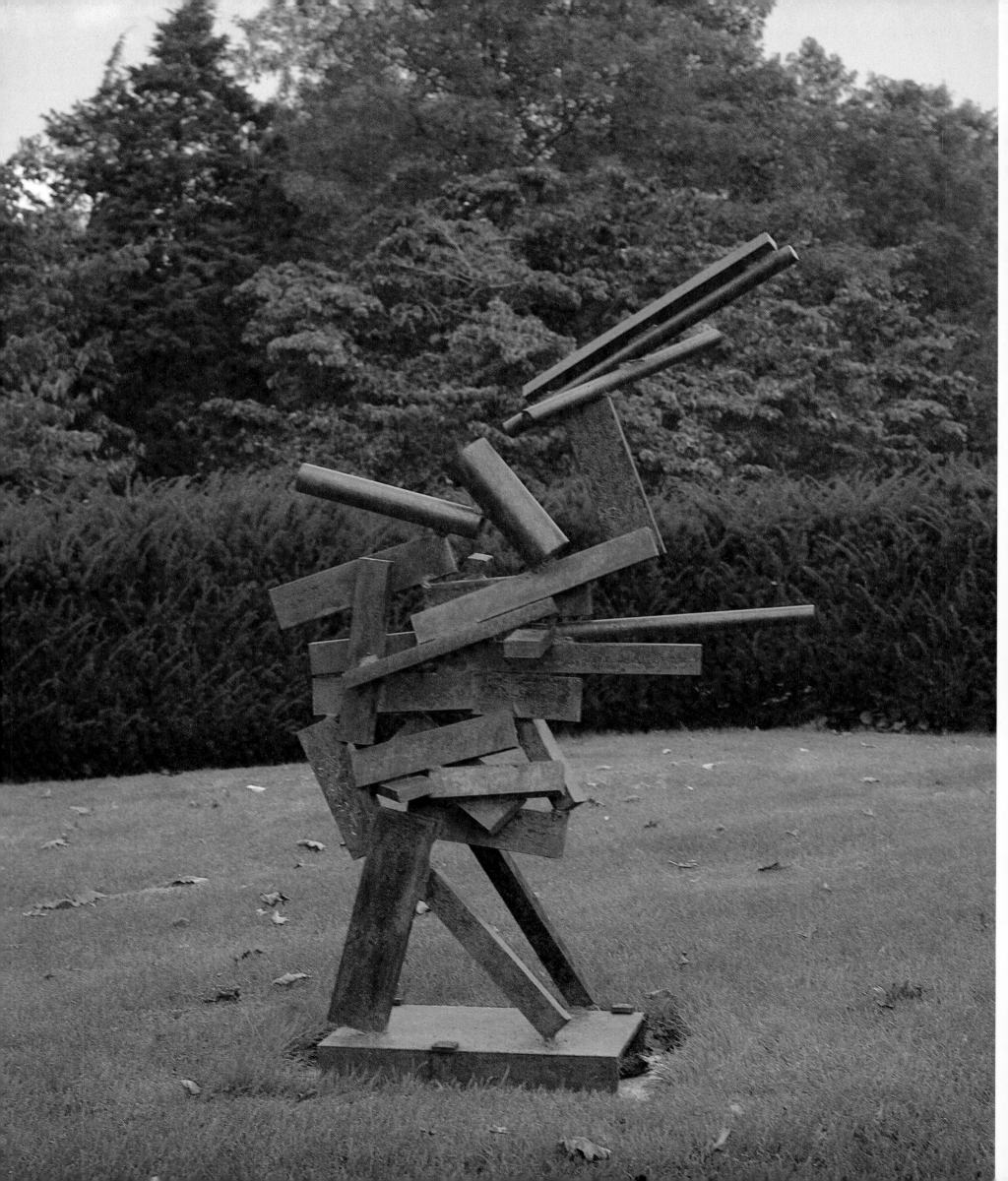

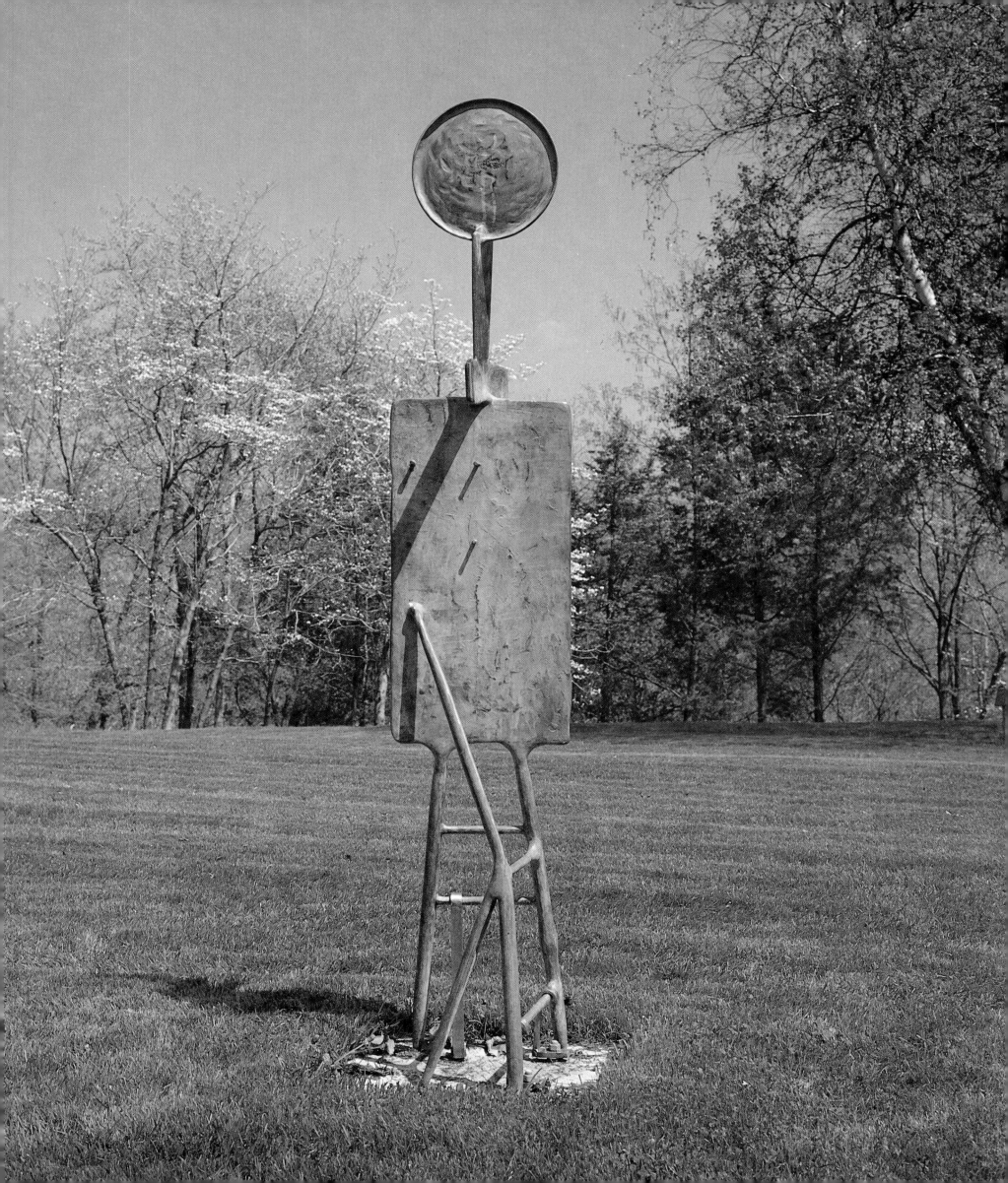

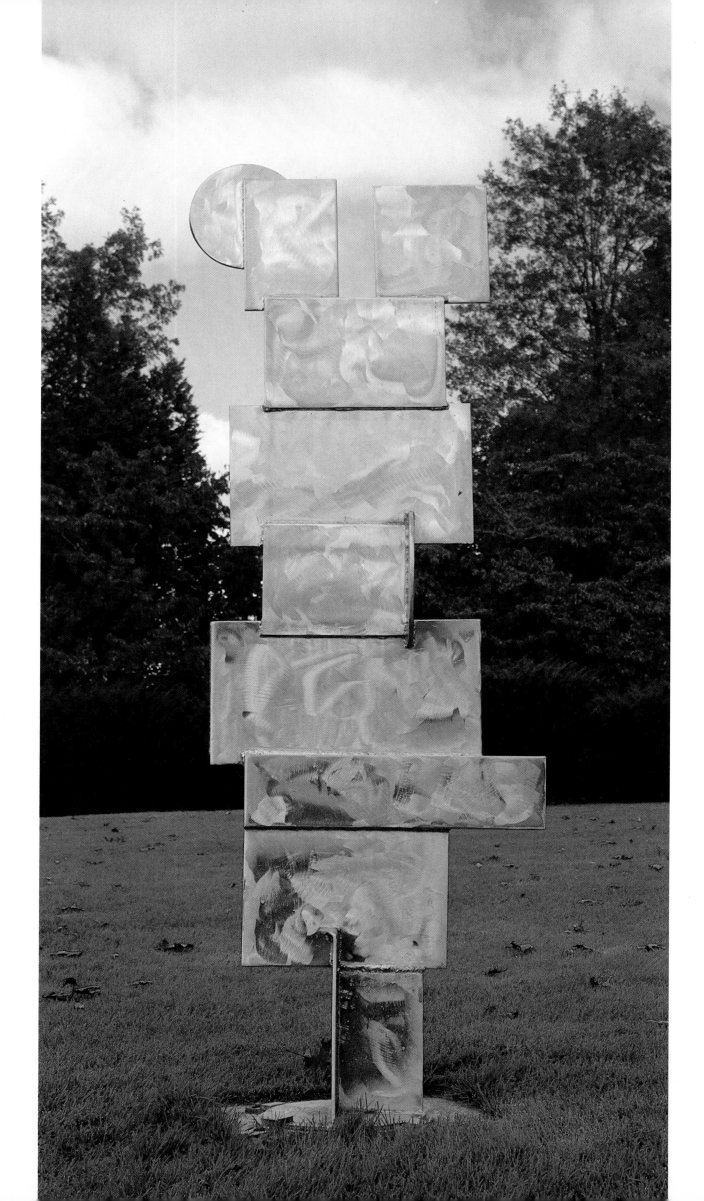

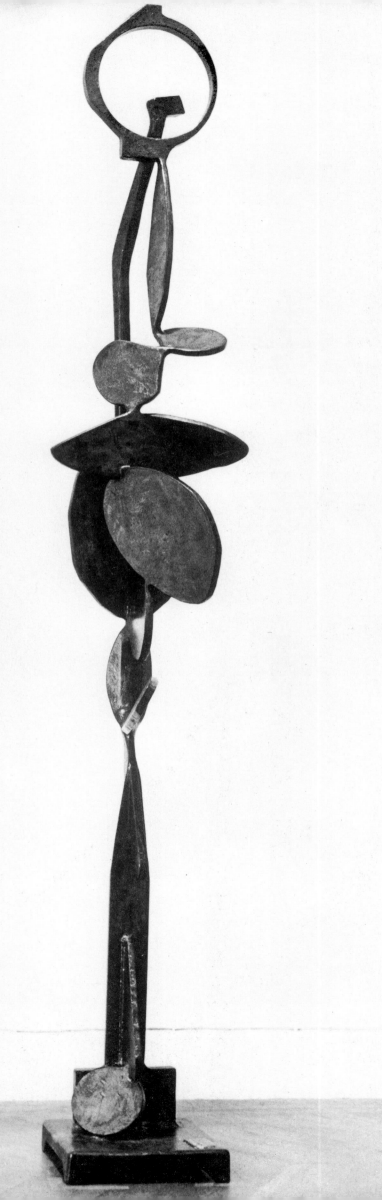

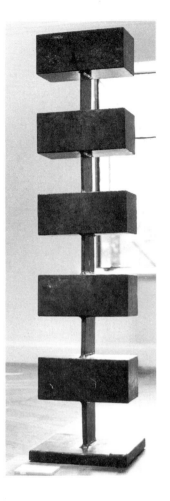

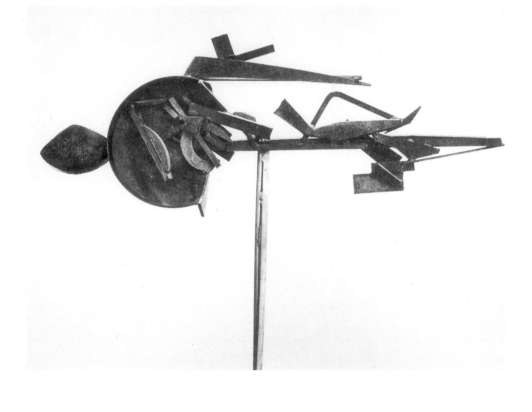

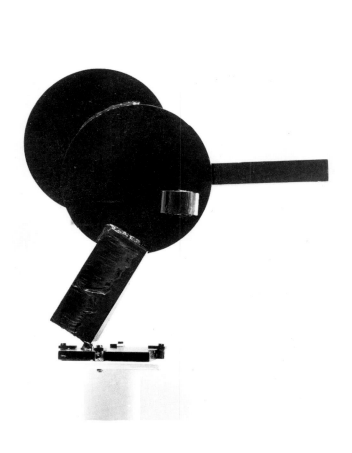

The brilliant images
of these David Smith
sculptures, placed indoors,
bear his unmistakable stamp.
"The Iron Woman" (facing
page left)
"Five Units Equal" (facing
page above)
"Raven V" (facing page below)
"Albany I" (above)
"Tank Totem VII" (right)

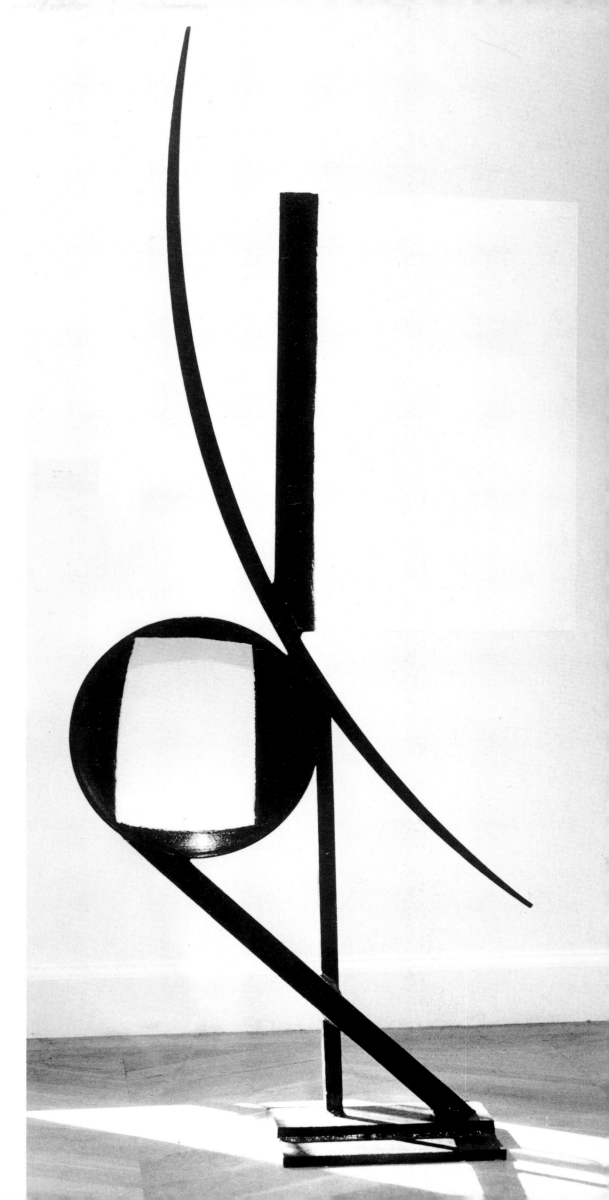

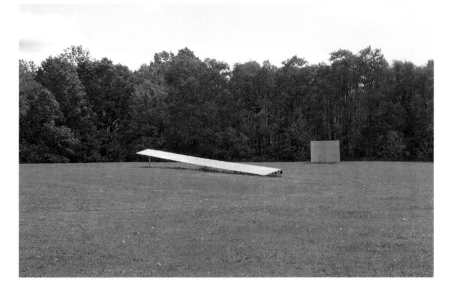

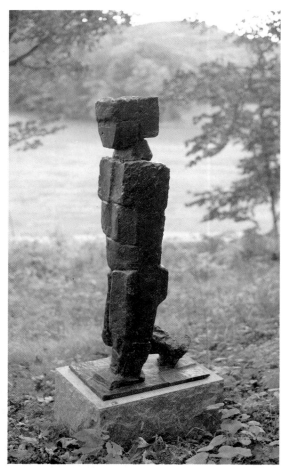

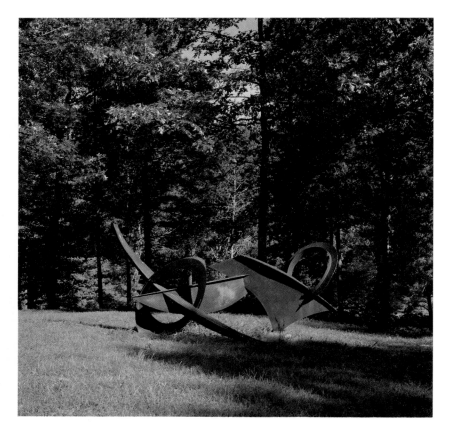

At the edge of forests, in the unclipped underbrush, or on neatly mowed greens, sculptures grow out of nature and reflect the shapes around them.

Two sculptures, both "Untitled," by David Von Schelgel (facing page upper right and left)

"Man Walking" by Fritz Wotruba (facing page, lower left)

"Konkapot II" by Herbert Ferber (facing page, lower right)

"Australia No. 9" by Richard Stankiewicz

"Ex" by Gilbert Hawkins (overleaf)

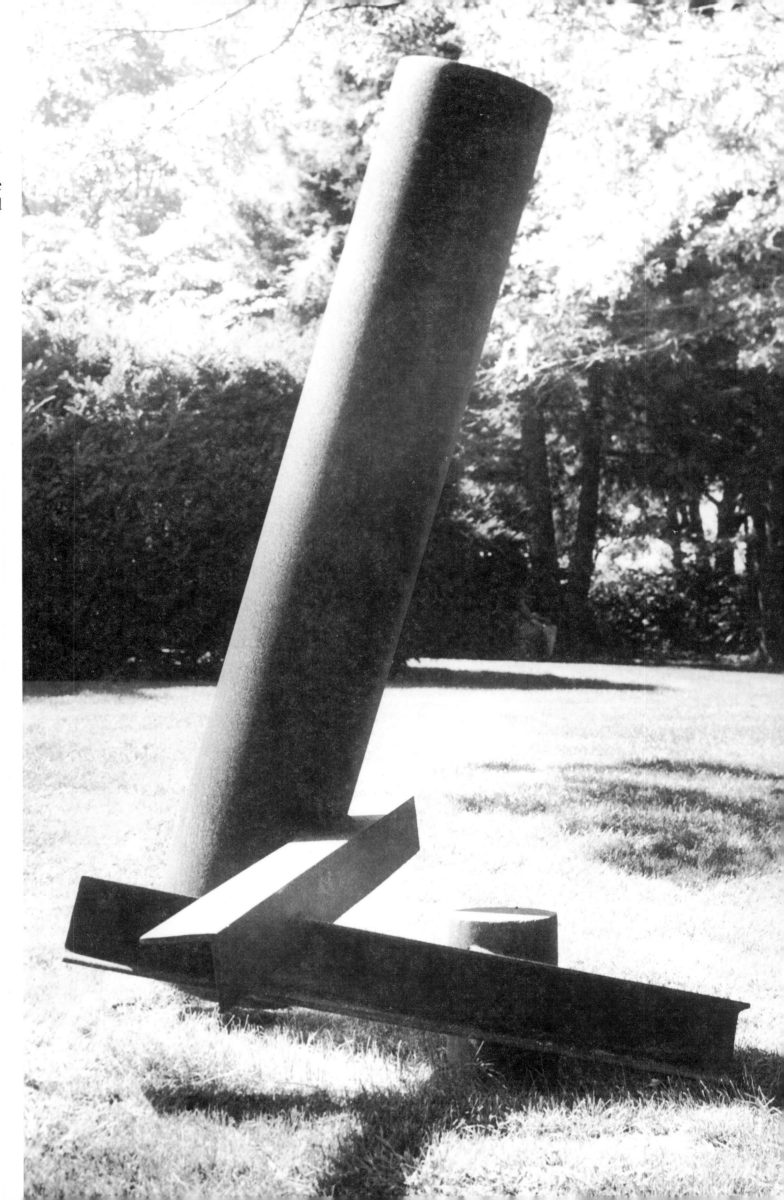

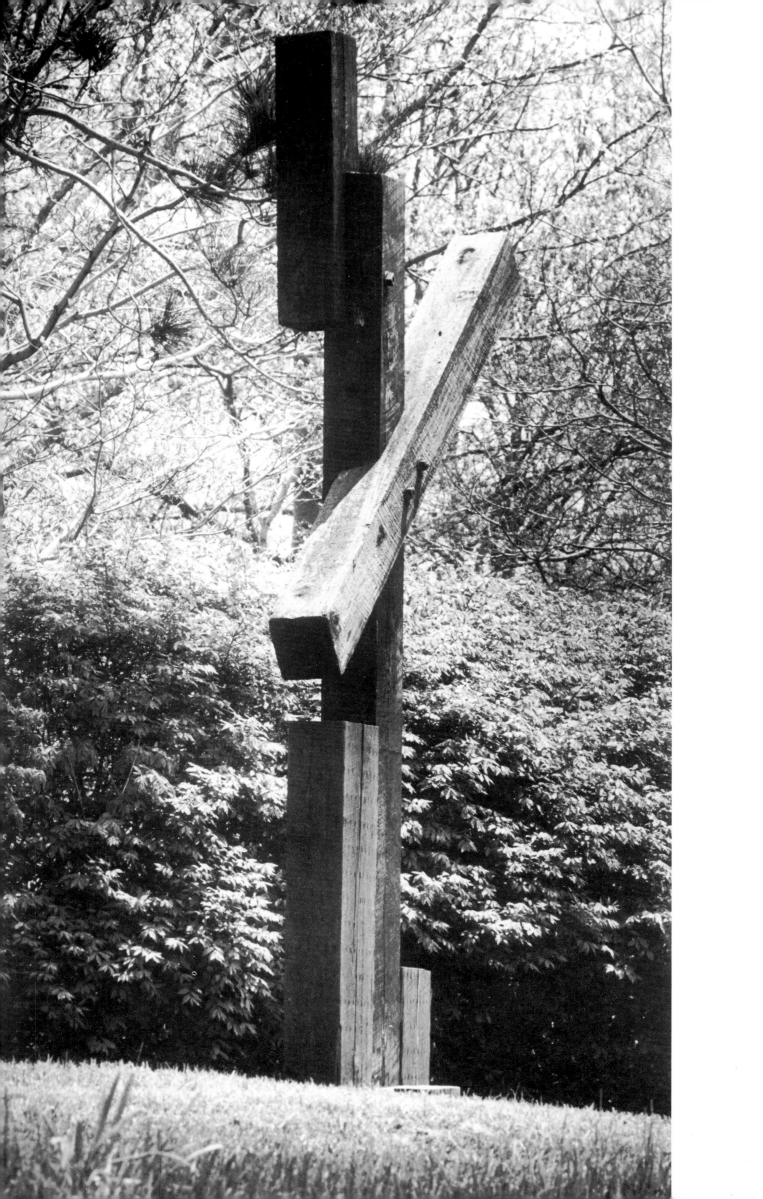

On the following pages:

With a grand sweep that easily encompasses the distant vistas of hills and valleys, this collection of Mark di Suvero sculptures are on loan from the artist and Richard Bellamy. The expansiveness of the setting provides a rare opportunity to see his monumental works from afar as well as close-up, and relate the balanced forms to the panoramic views one can see in all directions. The sculptures are "Mother Peace" (pp. 94–95); "Are Years What? (for Marianne Moore)" (p. 96); Mon Père, Mon Père (page 97); "Ik Ook" (p. 98); "One Oklock" (p. 99).

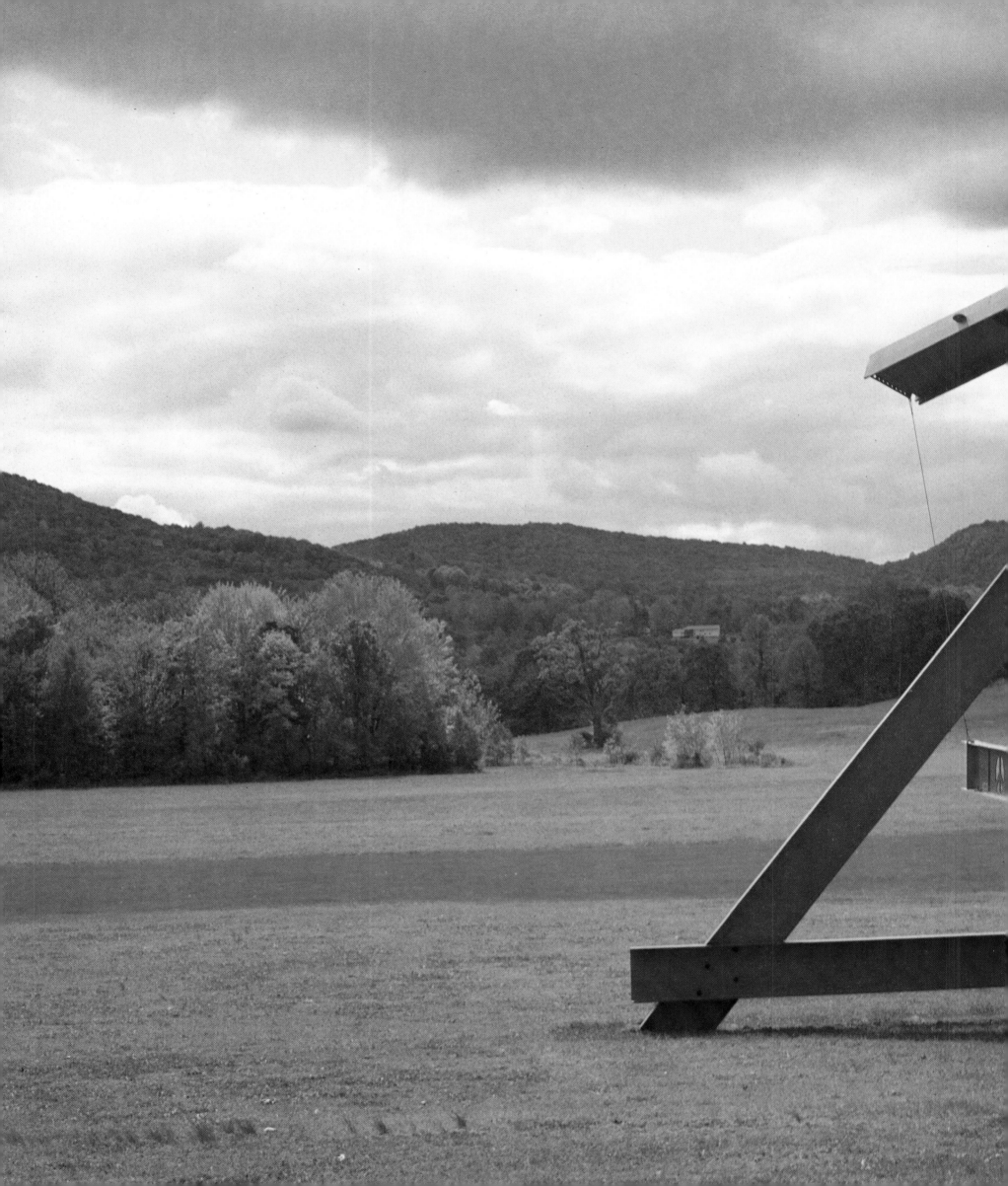

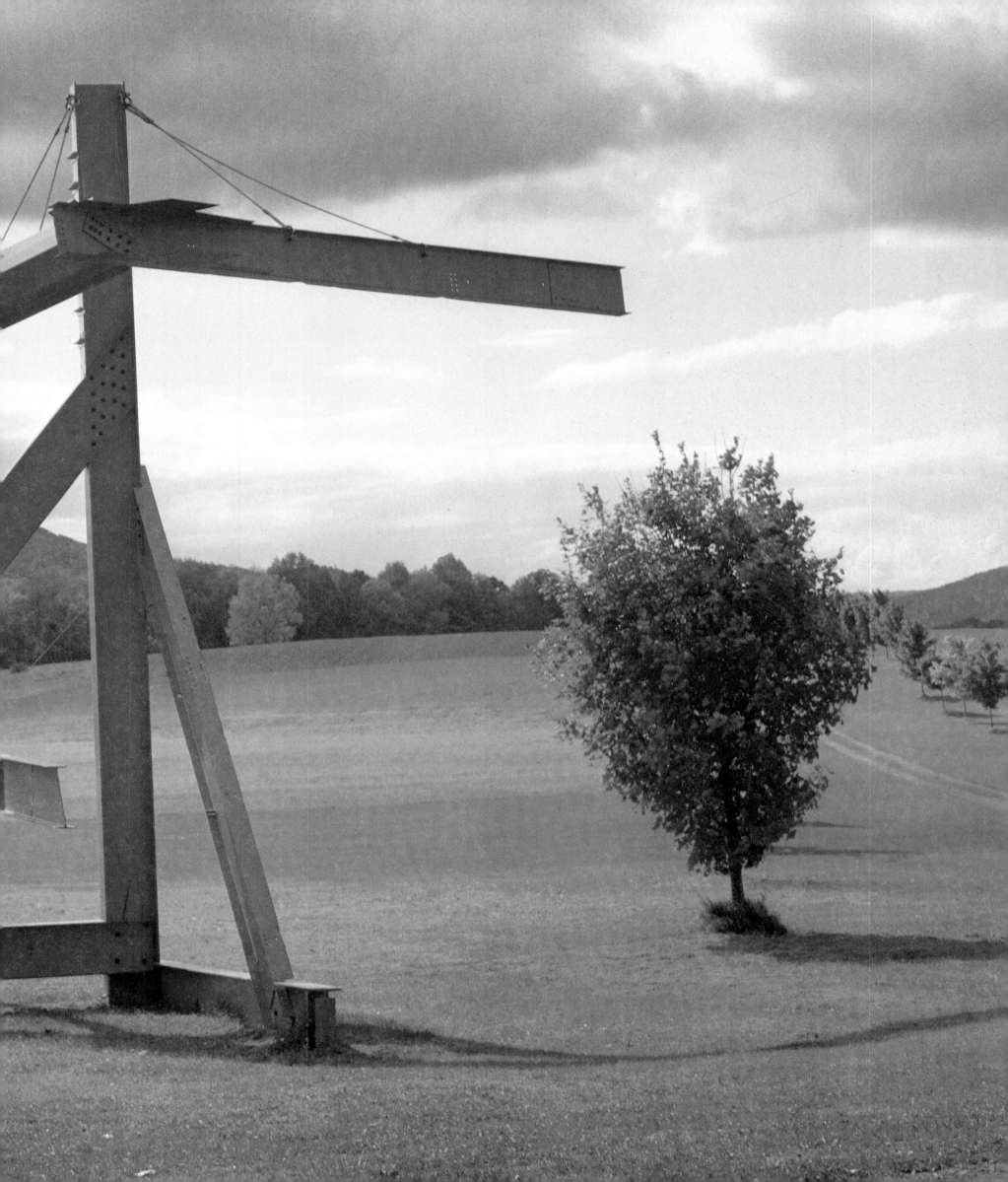

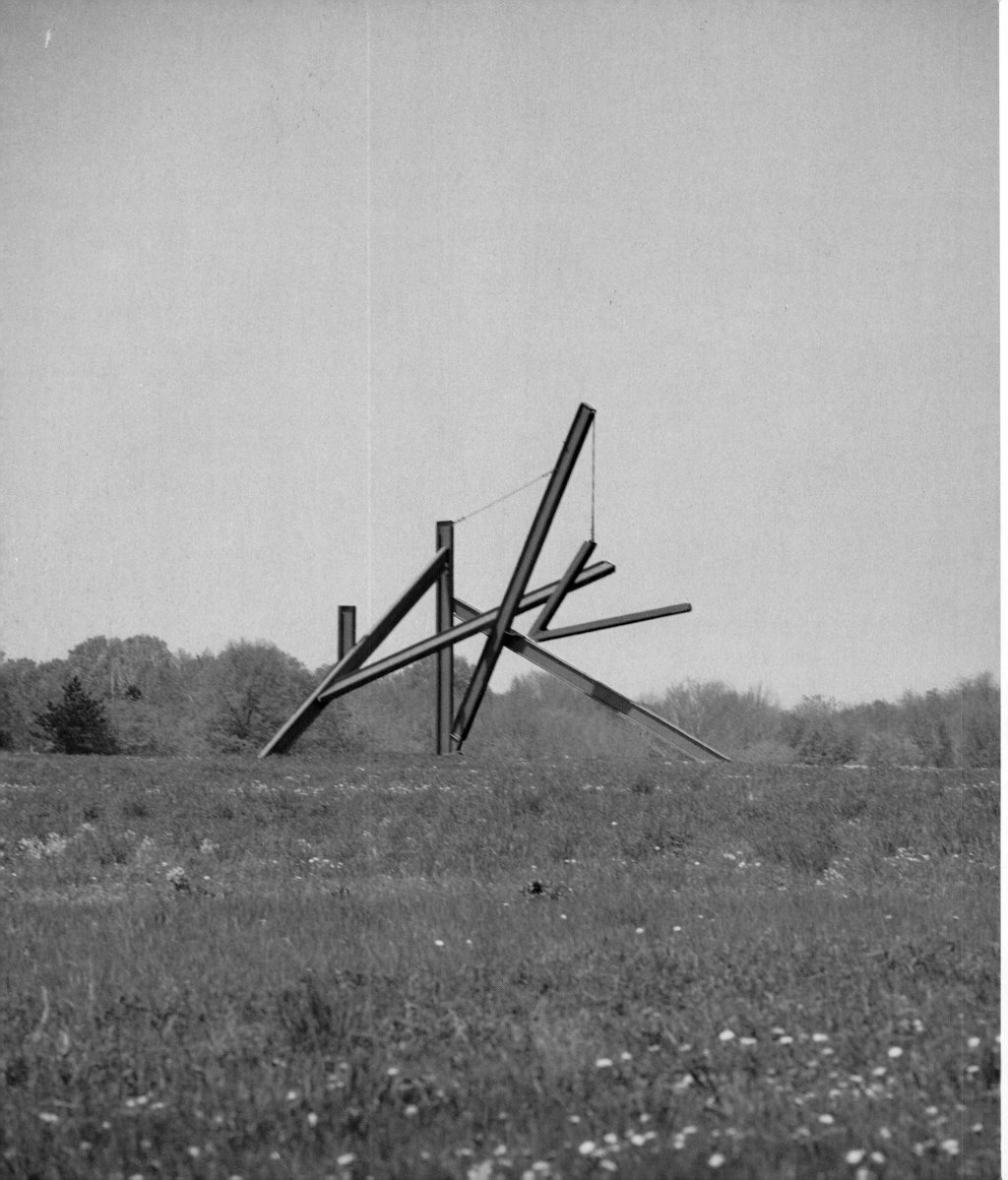

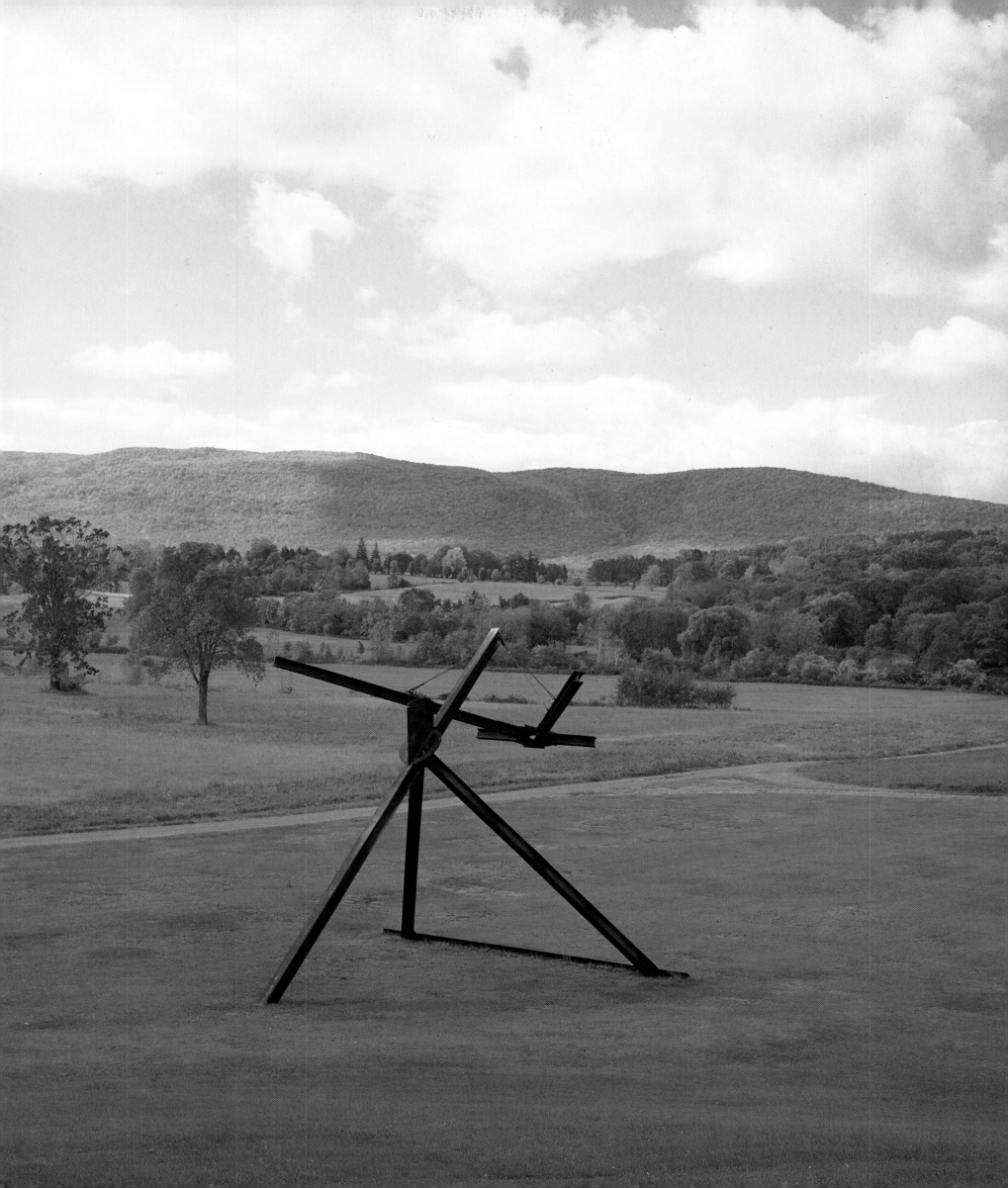

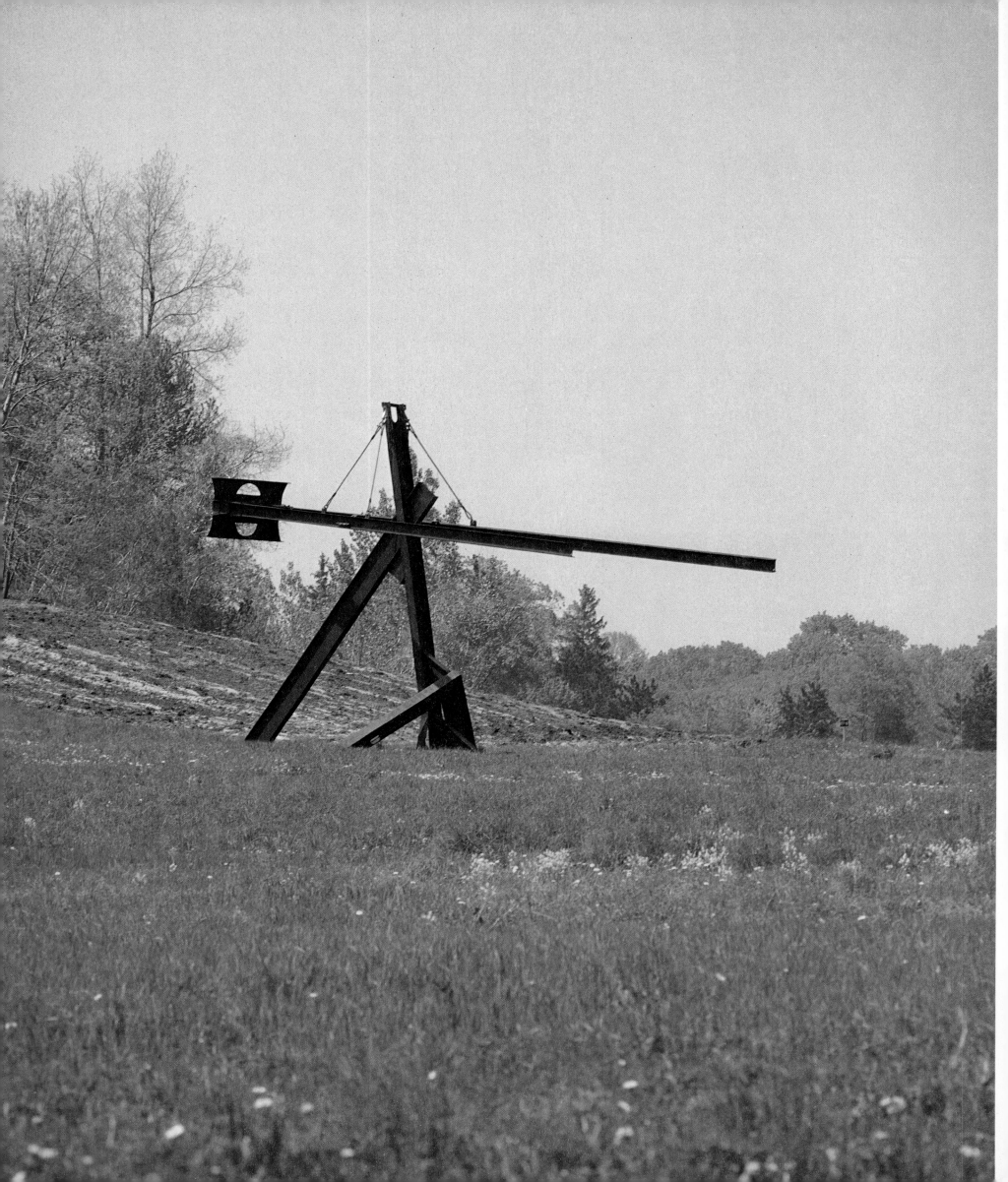

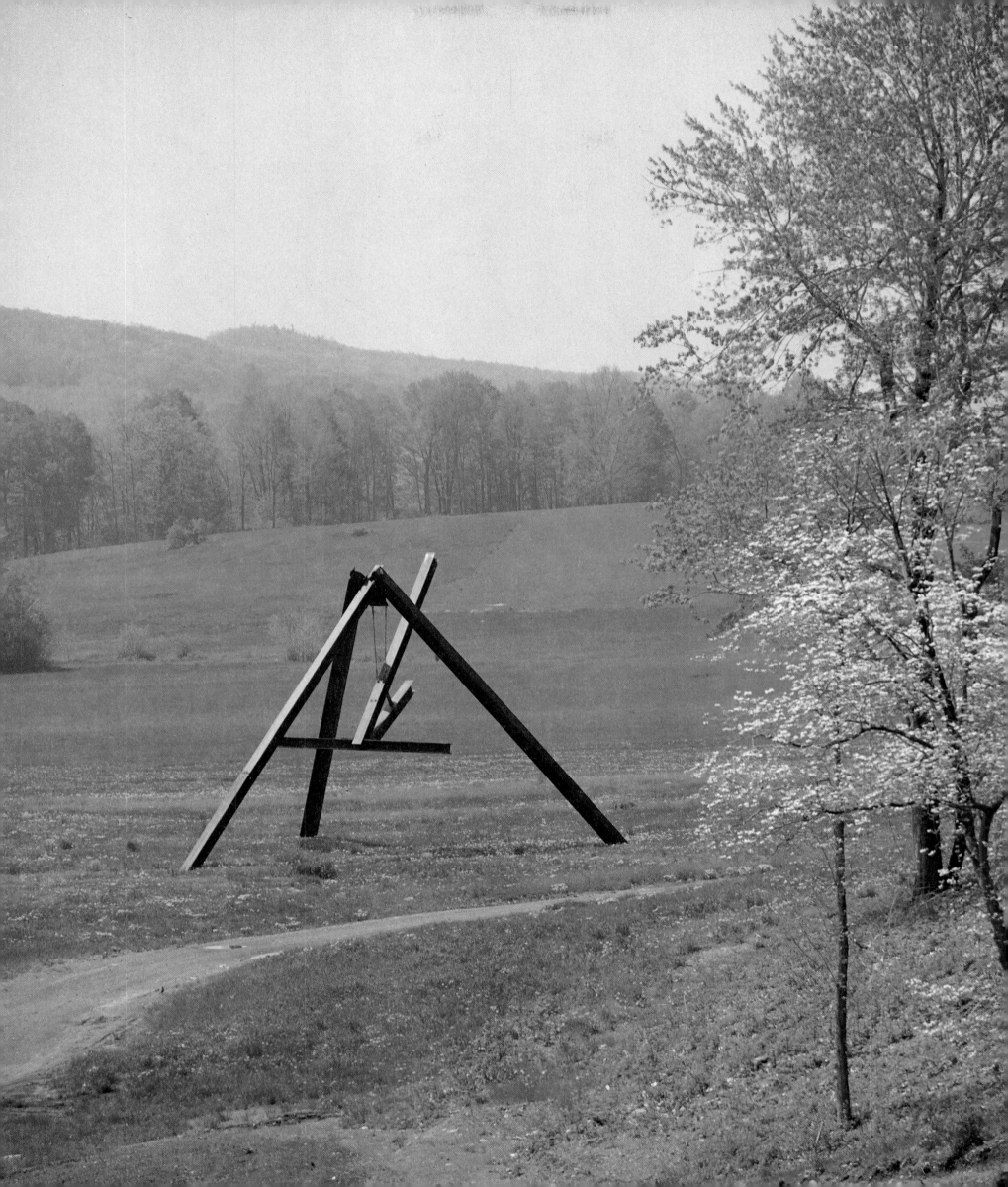

BIOGRAPHIES INCLUDING LIST OF ILLUSTRATED WORKS

Entries are listed alphabetically under the names of the artists. All sculptures are in the permanent collection of the Storm King Art Center except as noted. Works are listed chronologically; measurements appear in the following order: height, width, depth.

DAVID ANNESLEY
(born London, England, 1936)

Annesley studied sculpture at the St. Martin's School of Art, London (1958 – 62). Since 1936 he has lived in London and taught at the Croydon College of Art (1963 – 69), and the St. Martin's School of Art (since 1963). During a visit to the United States in 1966 the artist stayed with Kenneth Noland. Annesley works primarily in aluminum, but his interest in color in sculpture led him, in 1972, to begin painting as well.

Annesley has had one-person shows at the Waddington Gallery, London (1966, 1968, 1970, 1971), the Harlow Theater Gallery, Essex (1975), the Poindexter Gallery, New York (1966, 1968), and the Frank Watters Gallery, Syndey, Australia (1975). His group exhibitions include "26 Young Sculptors," Institute of Contemporary Arts, London, and the 2nd. Biennale de Paris (both 1961). In 1966 he participated in "Primary Structures" at the Jewish Museum, New York, and "Sculpture in the Open-Air," Battersea Park, London.

His works are in the collections of Nagaoka Museum, Japan; the Ulster Museum, Belfast, Ireland; the Art Galley of New South Wales, Sydney, Australia; and in London at the Tate Gallery, Gulbenkian Foundation, Victoria and Albert Museum, and the British Council.

Untitled, 1967
Aluminum (painted blue and white)
73½ × 112 × 20"

MAX BILL
(born Winterthur, Switzerland, 1908)

Bill studied at the Kunstgewerbeschule in Zürich from 1924 to 1927 and at the Bauhaus in Dessau, Germany, from 1927 to 1929. He has since worked as an architect, silversmith, journalist, and industrial designer, as well as a sculptor and painter. As co-founder and dean of the Hochschule für Gestaltung in Ulm between 1951 and 1956 and Professor of Environmental Design at the State Institute of Fine Arts in Hamburg from 1967 to 1974, he has attempted to realize an integration of all the arts.

Through the years, Bill refined his theory concerning the "Mathematical Approach in Contemporary Art" (*Werk,* no. 3, Winterthur, 1949), and in 1974 stated:

Today I know better that mathematics are only a part of the methods to be adapted for the regulation of so-called works of art. I know that a concept has to conform to its inner organization and its visual existence. This means that a concept and the finally executed work have to be a unity. This unity is the result of the logical approach to the solution of the problem and its realization.

I prefer today to describe this process as the logical approach to the problem of art. This means that every part of the creative process consciously follows step by step a logical analysis and feedback. This is the way I hope to realize my vision best.[1]

Bill has had numerous one-person exhibitions throughout Europe since 1928 and the United States since 1963. Major retrospectives of his work have been held at the San Francisco Museum of Art in 1970 and the Albright-Knox Art Gallery in Buffalo, New York, in 1974 – 75. Under the title "Concrete Art," Bill organized two important international exhibitions of abstract art, including his own work, at the Kunsthalle in Basel (1944) and the Kunsthaus in Zürich (1960).

In 1936 and 1951 Bill designed the Swiss pavilion for the Milan Triennale, receiving the Grand Prize in 1951. He has also been awarded the Kandinsky Prize, Paris (1949); the first International Prize for Sculpture at the Sao Paulo Bienal (1951); the Gold Medal of the Italian Chamber of Deputies, Verucchio (1966); the Art Prize of the Prize of the City of Zürich (1968); and a prize at the First International Biennale of Small Sculpture in Budapest (1971).

Unit Of Three Elements, 1965
Granite
31 × 51½ × 38"

[1]Naylor, Colin, and Genesis P-Orridge, eds. *Contemporary Artists,* (London: St. Martin's Press Inc., New York, 1977) p. 111.

HELAINE BLUMENFELD
(born Cambridge, England, 1938)

Blumenfeld received her Ph. D. in philosophy from Columbia University in New York City, and in 1962 studied sculpture with Ossip Zadkine in Paris. Her first one-person show was held in Vienna at the Palais Palfi in 1966, and was followed by exhibitions in New York City at the Chapman Gallery in 1968, and the Bonino Gallery since 1972. She has also exhibited her abstract bronze and marble pieces in Warsaw, Paris, London and Spoleto.

Presently Blumenfeld lives in Cambridge, England, and creates her work in Pietrasanta, Italy.

Dependence, 1974
Marble
34"

ALEXANDER CALDER
(born Philadelphia, Pennsylvania, 1898; died New York City, 1976)

Calder took mechanical engineering at the Stevens Institute of Technology in Newark, New Jersey, from 1915 to 1919. He studied at the Art Students League in New York City with John Sloan, George Luks, Guy Pène du Bois, and Boardman Robinson, from 1923 to 1926, during which time several of his line drawings were published in the *National Police Gazette.* In 1927 he visited Paris for the first time and exhibited circus toys and wire sculptures at the Salon des Humoristes. During subsequent stays in Paris in the 30s he met Miró, Mondrian, Léger, and other artists of the avant-garde, and developed the stabiles and mobiles for which he is best known. Calder has also designed ballet sets, jewelry, and tapestries, in addition to producing a large selection of drawings, graphics, and gouaches.

During his last twenty years, Calder was increasingly occupied with large outdoor stabiles, fabricated in painted steel. These are located in Spoleto, Chicago, Mexico City, Paris, Montreal, Grand Rapids, and other cities throughout the world. Calder himself divided his time during this period between his studios in Sache, France, and Roxbury, Connecticut.

In his first one-person exhibition in 1928, Calder showed wire sculpture at the Weyhe Gallery in New York City. His first mobiles were shown in 1932 at the Galerie Vignon in Paris. Calder was represented by and showed regularly at the Pierre Matisse Gallery (1934 – 43) and Perls Gallery (1953 – 77). Retrospectives of his work have been held at the

Springfield (Mass.) Museum of Fine Arts (1938); The Museum of Modern Art, New York (1943); the Stedelijk Museum, Amsterdam (1947, 1959, 1968); the Walker Art Center, Minneapolis, Minn. (1953); the Museo de Arte Moderno, Rio de Janeiro (1959 – 60); Tate Gallery, London (1962); the Museum of Fine Arts, Houston (and other U. S. museums, 1964 – 65); the Akademie der Kunst, Berlin (1967); the Long Beach (Calif.) Museum of Art (1970); the Solomon R. Guggenheim Museum, New York (1964 – 65); the Whitney Museum of American Art, New York (and other U. S. museums, 1976 – 79). Most museums throughout the world featuring modern art own at least one work by Calder.

Among his many awards, Calder won the first prize in the Plexiglas Sculpture Competition of the Museum of Modern Art, New York (1939); the First Prize for Sculpture at the Venice Biennale of 1952; a sculpture prize at the Sao Paulo Bienal of 1953; the first prize of the Carnegie International, Pittsburgh (1958); the Gold Medal of the Architectural League, New York (1960); the Creative Arts Award of Brandeis University, Waltham, Mass. (1962); and the Gold Medal of the Institute of Arts and Letters, Washington, D. C. (1971).

Seven Foot Beastie, 1957
Steel plate (painted black)
84 × 84 × 48″

Sandy's Butterfly
Stainless sheet steel and iron rods, painted
12′ 8″ × 110″ × 103″
Museum of Modern Art, New York
Gift of the artist, 1966

The Tall One, 1968
Steel plate (painted black)
12′ × 75″
Estate of Alexander Calder and Knoedler Gallery

Flamingo, 1973
Steel plate (painted orange)
12′ 1¼″ × 14′ 11½″ × 75″
Estate of Alexander Calder and Knoedler Gallery

The Arch, 1975
Steel plate (painted black)
56′ × 44′ × 36′
Estate of Alexander Calder and Knoedler Gallery

KENNETH CAMPBELL
(born West Medford, Massachusetts, 1913)
Campbell pursued his studies at the Massachusetts College of Art, Boston (1933 – 37), with Ernest Major and Richard Andrews; the National Academy of Design, New York City (1937 – 40),

with Leon Kroll and Gifford Beal; and the Art Students League, New York City (1937 – 40), with Arthur Lee and Vatclav Vytlacil. He also studied engineering and worked as an industrial designer and modelmaker. Later he taught at Silvermine College of Art, New Canaan, Connecticut (1962 – 63), and Queens College, New York City (1963 – 66).

Orginally a painter, Campbell turned to sculpture in 1954. He carves directly in marble, granite, and limestone and is known for his technique of positioning stones, one upon the other, in a precarious way that challenges gravity.

Campbell's first one-person show of paintings was held in 1947 at Smith Gallery, Boston, Massachusetts. During that year he established the Studio Five School of Creative Painting in Boston and Provincetown. His first individual show of sculpture was at Camino Gallery, New York City, in 1960. His work has appeared in group shows at the Solomon R. Guggenheim Museum, New York City (1948), the International Sculpture Symposia, Proctor, Vermont (1968 and 1970) among many others. In 1967 a retrospective of his painting and sculpture was held at the University of Kentucky.

Campbell received the Ford Foundation Purchase Award for 1963 – 64 and the Guggenheim Fellowship for 1965. His work is in the collections of the Walker Art Center, Minneapolis, Minnesota, Whitney Museum of American Art, New York City, and other museums.

Persephone Returns, 1965
Marble
80¼ × 20½ × 22¼″

KENNETH CAPPS
(born Kansas City, Missouri, 1939)
Capps attended Palomar College, San Marcos, California, in 1971 and received his M. F. A. in 1975 at the University of California, San Diego. His steel-bolted timber sculptures have been shown in one-person exhibitions at the University of California, San Diego (1975), and at the O. K. Harris Gallery, New York City (1976 and 1977), and in group exhibitions at the Fine Arts Gallery, San Diego (1973), California State University (1974), and the Oakland Museum (1974). Works by the artist can be found in the Sculpture Park, Düsseldorf, Germany, the Aldrich Museum of Contemporary Art, Ridgefild, Connecticut, and the Neuberger Museum, Purchase, New York. In 1974 he won the Purchase Award of California State University.

Strike, 1972
Wood and metal
96 × 96 × 36″

ANTHONY CARO
(born London, England, 1924)
Caro studied engineering at Christ's College, Cambridge, England (1942 – 44), and sculpture at the Polytechnic, London (1946), and the Royal Academy of Arts, London (1947 – 52). He worked as an assistant to Henry Moore from 1951 to 1953. The artist taught at St. Martin's School of Art, London (1952 – 53, 1964 – 73), and at Bennington College, Vermont (1963 – 64 and 1965).

From 1954 to 1959 Caro created expressionistic figures out of bronze. In 1959 he started working in prefabricated steel after visiting the United States and seeing sculptures by the late David Smith. His large horizontal sculptures rest on the ground and are not confined to a base or pedestal but develop as highly sophisticated and suggestive improvised compositions. Color was an integral part of his work until the early 1970's when he began to leave his steel surfaces unpainted.

Caro's work was first shown in a group exhibition at the Institute of Contemporary Art, London (1955), but his first one-person exhibition was held in Milan at the Galleria del Naviglio (1956). In New York, Caro has been represented by the André Emmerich Gallery since 1964, and in London by the Kasmin Gallery since 1965. Retrospectives of his work have appeared at the Hayward Gallery, London (1969), and the Museum of Modern Art, New York City (and other U. S. museums, 1975 – 77).

His sculptures are included in the collections of the Tate Gallery, London, the Philadelphia Museum of Art, The Museum of Modern Art, New York City, and most of the world's major museums of contemporary art. In 1955 he received the Biennale de Paris Sculpture Prize, in 1966 the David Bright Sculpture Prize at the Venice Biennale, and the Sculpture Prize at the 1969 Sao Paulo Bienal.

Reel, 1964
Steel (painted red)
34¼ × 107 × 37¾″

Seachange, 1970
Steel (painted grey)
35 × 111 × 60″

DOROTHY DEHNER
(born Cleveland, Ohio, 1901)
Dehner attended school at the University of California at Los Angeles, 1920 – 21. After a trip to Europe in 1925, she studied intermittently at the Art Students League, New York City, with Kimon Nicolaides, Kenneth Hayes Miller, and Jan Matulka (1925 – 1932). She resumed her education at Skidmore College, Saratoga Springs, New York (1951 – 52),

and then learned the various techniques of printmaking at Stanley Hayter's Atelier 17, New York City (1952 – 55).

Dehner was a painter until the 1950's, when she started making sculptures in bronze. More recently she has turned to painted and natural wood. She is also an accomplished draftsperson and printmaker. Her writings include "The Fifteen Medallions of David Smith" (*Art Journal,* winter, 1977 – 78), the foreword for John D. Graham's book *System and Dialectics of Art* (Johns Hopkins Press, 1971), articles and art reviews for *Architectural Forum*, and the foreword for a catalogue of the Jan Matulka exhibition at the Whitney Museum of American Art, New York City (1979).

A joint show with her husband, David Smith, at the Albany Art Institute, Albany, New York in 1948, was followed by an individual show there in 1954. She was honored with a retrospective at the Jewish Museum, New York City in 1965. Other one-person shows were held at the Rose Fried Gallery, New York City (1952), the Art Institute of Chicago, Illinois (1955), the Willard Gallery, New York City (several between 1957 and 1973), Cornell University, Ithaca, New York (1964), the Fort Wayne Museum of Art, Indiana (1965), and the Marian Locks Gallery, Philadelphia, Pennsylvania (1977).

In New York City, she participated in the Annuals of the Whitney Museum of American Art in 1950, 1951, 1954, 1960 and 1963, and in group exhibitions at The Metropolitian Museum of Art (1953), The Museum of Modern Art (1954 and 1964), and the Solomon R. Guggenheim Museum (1961). Her work has also appeared in group shows at the Corcoran Gallery of Art, Washington, D. C. (1973); the Walker Art Center, Minneapolis, Minnesota; the Carnegie Institute, Pennsylvania (1963); and in Ohio at the Cleveland and Cincinnati Museums.

Dehner's works are in the collections of The Metropolitan Museum of Art, and The Museum of Modern Art, New York City; the Philadelphia Museum of Art, Pennsylvania; the Hirshhorn Museum and Sculpture Garden, Washington, D. C.; the Phoenix Art Museum, Arizona; the Birla Institute of Art, Calcutta, India; and the University of New Mexico.

Sculpture commissions have been completed by Dehner for the American Telephone and Telegraph Building, Basking Ridge, New Jersey; Rockefeller Center, New York City (1972); and the Union Camp Corporation, New Jersey (1971).

In 1947, the artist was awarded the Audubon Artists First Prize for Drawing. She was also given the First Prize for Sculpture at the Kane Memorial Exhibition in Providence, Rhode Island (1965), the Yaddo Foundation Fellowship (1971), and the Tamarind Lithography Workshop Fellowship (1970 – 71).

Cenotaph IV, 1972
Aluminum and bronze
75½ × 5¾ × 5¾"

MARK DI SUVERO
(born Shanghai, China 1933)

Di Suvero was born in China of Italian parents and moved to California with his family in 1941. He majored in philosophy at the University of California, both at Santa Barbara and Berkeley, studying sculpture first with Robert Thomas, then with Stephen Novak. His early works combined found objects of lumber, metal and rubber. Recent largescale outdoor steel structures, as well as smaller intimate pieces, incorporate moving elements that invite audience participation.

After moving to New York in 1957, di Suvero had his first one-person show at the Green Gallery in 1960. In Europe, where he lived in the early 1970's, he was given major exhibitions at the Stedelijk Vanabbemuseum in Eindhoven, The Netherlands (1972); in Chalon-sur-Saone, France, where he showed monumental works made during residence at the town's steel works from 1972 to 1974; and at the Tuileries Gardens in Paris (1975), where he was the first contemporary sculptor to be honored with a one-person exhibition. Di Suvero's retrospective at the Whitney Museum in New York (1975 – 76) included twelve monumental works at outdoor sites in the city.

Among his commissions, di Suvero has created works for the General Services Administration at Grand Rapids, Michigan (1977) and the Institute of Scrap Iron and Steel at the Hirshhorn Museum and Sculpture Garden, Washington, D. C. (1978). Di Suvero received the Logan Medal and Prize sponsored by the Art Institute of Chicago (1963), Skowhegan Medal for Sculpture (1974) and an honorary Doctorate of Fine Arts, Maryland Institute (1978).

His works are included in the Collections of the Hirshhorn Museum and Sculpture Garden, Washington, D. C.; the Los Angeles County Museum of Art, California; the Wadsworth Atheneum, Connecticut; the Whitney Museum of American Art, New York; the Detroit Institute of Arts, Michigan, and the St. Louis Art Museum, Missouri, among others.

Pre-Columbian, 1965
Wood, steel, iron and rubber
98" × 14' 3" × 110½"

LENT BY THE ARTIST AND RICHARD BELLAMY:
Are Years What ? (for Marianne Moore), 1967
Steel (painted orange)
40 × 40 × 30'

One Oklock, 1968 – 69
Steel
h. 45'

Mother Peace, 1970
Steel (painted orange)
39' 6" × 38' 5" × 32' 8½"

Ik Ook, 1971 – 72
Steel
24 × 24 × 33'

Mon Père, Mon Père, 1973 – 75
Steel
35' × 40' × 40'4"

HENRI ETIENNE-MARTIN
(born Loriol, France, 1913)

Etienne-Martin studied at the Ecole des Beaux-Arts in Lyons until 1933 and then at the Académie Ranson in Paris under the guidance and inspiration of Malfray. Since 1958 he has taught at the American School in Fontainebleau and since 1967 has been a professor of the Ecole des Beaux-Arts in Paris.

Affected in his development by a seemingly incompatible variety of influences — Marcel Duchamp, baroque artists and Surrealists, Bernini and Rodin — Etienne-Martin has experimented with various combinations of materials, using string as well as wood and bronze, and creating whole environments in his later works. Many of them relate to a constant theme, most notably that of *Night*, which first appeared in 1935.

In 1949, Etienne-Martin was awarded the Blumenthal Prize and the Prix de la Jeune Sculpture. He won the Grand Prize of the Venice Biennale in 1966 and the French Grand Prix National des Arts in 1967. He has had retrospectives at the Kunsthalle in Berne (1962), the Stedelijk Museum in Amsterdam (1963), and the Palais des Beaux-Arts in Brussels (1965). Examples of his work are owned by the Stedelijk Museum, the Museum of Modern Art in New York, and the Musée National d'Art Moderne in Paris, among others.

Le Bec, 1964
Bronze
28 × 59 × 26"

SOREL ETROG
(born Iasi, Romania, 1933)

Etrog began his formal studies in art under a family friend in Romania. In 1950 he immigrated to Israel with his family

and began to study at the Institute of Painting and Sculpture in Tel-Aviv in 1953. From 1956 to 1958 he attended the Brooklyn Museum Art School and lived in New York until 1961, when he moved to Toronto. Since his first one-person show at the Gallery Moos in Toronto (1959), he has shown extensively in the United States, Canada, Europe, and Israel and has been honored with retrospectives at the Palazzo Strozzi in Florence, Italy (1968), and the Art Gallery of Ontario, Toronto (and other Canadian museums, 1968 – 69).

Etrog is represented in the collections of Rijksmuseum Kröller-Müller, Otterlo, The Netherlands; the Solomon R. Guggenheim Museum in New York; the Israel Museum, Jerusalem; the Tate Gallery, London; and the Art Gallery of Ontario.

Etude de Mouvement, 1965
Bronze
48½ × 13½ × 10"

Large Pulcinella, 1965 – 67
Bronze
107 × 50 × 20½"

HERBERT FERBER
(born New York City, 1906)

Ferber took a degree in dentistry and oral surgery at Columbia University in 1927 and studied art at the Beaux Arts Institute of Design (1927 – 30) and the National Academy of Design (1930), both in New York.

In 1937, Ferber had his first one-person show at the Midtown Galleries in New York. He was represented by the André Emmerich Gallery from 1960 to 1976. Since 1977 the artist has been represented by Knoedler Gallery. He has been given retrospectives at Bennington College Vermont, (1958); the Whitney Museum of American Art, New York (1961); the Walker Art Center, Minneapolis (and other U. S. museums, 1962 – 63); the University of Vermont (1964); and Rutgers University, New Brunswick, New Jersey (1968). Ferber's work has also appeared in Documenta II, Kassel, Germany (1959); the Musée Rodin, Paris (1965); Monumenta, Newport, Rhode Island (1974); and other important group shows.

Among his commissions are works created for Brandeis University, Waltham, Massachusetts (1955); Rutgers University (1967 – 68); the John F. Kennedy Federal Office Building, Boston (1969); and the American Dental Association Building, Chicago (1974).

Ferber has been awarded The Victory Prize of The Metropolitan Museum in New York (1942), the prize for the International Unknown Political Prisoner

Competition at the Institute of Contemporary Art, London (1953), and a Guggenheim Foundation Fellowship (1969).

Konkapot II, 1972
Cor-ten steel
69 × 48 × 118"

ROLAND GEBHARDT
(born Paramaribo, Surinam, 1939)

Gebhardt studied with Theo Ortner at the Art Academy in Hamburg, Germany, where in 1962 he was awarded the Annual Prize. He also attended the Kunstgewerbeschule in Zürich, Switzerland.

A one-person exhibition of his sculpture and painting was shown at the Hudson River Museum, Yonkers, New York, in 1971. The following year, his work appeared in the Twentieth-Century Sculpture Show at the Westchester Collection in Yonkers. In 1973, Gebhardt exhibited at Gallery 84; in 1974 and again in 1977 at the Carleton Gallery; and in 1978 at the Robert Freidus Gallery — all in New York City.

Gebhardt has participated in several group shows, among them: the Aldrich Museum "Minimal Tradition" show in 1979; the New York Institute of Technology in Old Westbury, New York, in 1978; Wards Island, Institute of Technology in Old Westbury, New York, in 1978; Wards Island, New York, in 1978; the P. S. 1 "Miniature Golf" show in Queens, New York; and the "Four Sculptors" show at the Robert Freidus Gallery in New York City, also in 1978.

The artist's sculptures are in the collections of Brandeis University, Waltham, Massachusetts; the Neuberger Museum, Purchase, New York; and in Germany at the Art Academy, Hamburg, and the city of Ludwigshafen.

Untitled, 1974
Polyester, sand and fiberglass
112 × 60 × 42"

CHARLES GINNEVER
(born San Mateo, California, 1931)

Ginnever studied sculpture with Ossip Zadkine at the Académie de la Grande Chaumière, Paris (1953 – 55) and graphics at Atelier 17, with Stanley Hayter (1955). He then attended the San Francisco Art Institute (1955 – 57) and received his M.F.A. at Cornell University in Ithaca, New York, in 1959.

Ginnever, with Mark di Suvero, was one of the early sculptors, in the late 1950s and early 60s, to realize the possibilities of found construction materials, lumber, and industrial metal. His more recent works intricately balance geometric shapes, particularly parellelograms,

in configurations that suggest flight.

Since his first one-person show at the Allan Stone Gallery in New York (1961), Ginnever has shown individually at Bennington College in Vermont (1965), the "10 Downtown" loft show (1968), the Paula Cooper Gallery (1970 and 1972), and Sculpture Now (1975), all in New York. He has also participated in group shows at the San Francisco Museum of Art (1956), Cornell University (1961), Oberlin College in Ohio, the Indianapolis Museum of Art, and the Walker Art Center in Minneapolis (1976).

Fayette: For Charles and Medgar Evars, 1971
Cor-ten steel
100" × 16' 6" × 18"

1971
Cor-ten steel
42" × 11' × 18"

EMILIO GRECO
(born Catania, Sicily, 1913)

The graceful, classical lines of Greco's bathers and dancers are in the tradition of Giacomo Manzù. As a young man, he trained as a sculptor in the workshop of a marble mason. While in the army, he joined the Academy in Palermo, and later went to Rome, where he held his first one-person show in 1946 at the Cometa Gallery. The artist's bronze figures have since been shown in important national and international exhibitions throughout the world. Among Greco's numerous awards are the Saint-Vincent Prize for Sculpture (1948), the prize of the municipality of Venice given at the 28th Biennale in 1956, and the prize of the 6th Quadriennale in Rome.

The Tall Bather I, 1956
Bronze
84½ × 18¼ × 28"

ROBERT GROSVENOR
(born New York City, 1937)

Grosvenor studied painting at the Ecole des Beaux Arts in Dijon, France (1956), followed by two years at the Ecole Nationale des Arts Décoratifs in Paris, where he studied architecture and naval design. He also attended the University of Perugia in Italy (1958). Originally a painter, he turned to sculpture in the early 60s and joined nine other artists, including Mark di Suvero, in founding the Park .Place Gallery in New York (1962).

Represented by the Paula Cooper Gallery in New York since 1971, Grosvenor has also had one-person shows at galleries in Cologne, Milan, Basel, Paris, and Naples. He participated in the "Primary

Structures" exhibition at the Jewish Museum in 1966, "Sculpture for the '60s" at the Los Angeles County Museum of Art in 1967, "Sonsbeek 71: Beyond Law and Order" in Arnhem, The Netherlands, and "Monumenta" in Newport, Rhode Island, in 1974.

Grosvenor has received grants from the Guggenheim Foundation (1969), the National Endowment for the Arts and Humanities (1970), and the American Academy of Arts and Letters (1972). His work can be found in the Hirshhorn Museum and Sculpture Garden, Washington, D.C.; the Walker Art Center, Minneapolis; and in New York City at the Whitney Museum of American Art and The Museum of Modern Art.

Untitled, 1974
Cor-ten steel (painted black)
9′ × 204′ × 1½′

GILBERT HAWKINS
(born New York City, 1944)

Hawkins received his B.F.A. from the Philadelphia College of Art in 1968. He also attended the New School for Social Research and the Art Students League in New York City. During 1969 – 70 Hawkins was a member of the Peace Corps in Upper Volta, Africa, where he helped organize an Arts Center.

While artist-in-residence at the Dwight Morrow High School in Englewood, New Jersey (1970-1974),Hawkins also taught at Fairleigh Dickinson University in Teaneck, New Jersey (1972 – 74). He then taught at Sarah Lawrence College in Bronxville, New York (1974 – 76),where he was also given a one-person show in 1976, and is presently director of Project Interaction in Demarest, New Jersey.

His work has also appeared in group exhibitions at the New Jersey State Museum in Trenton (1972), Co-op City in the Bronx, New York (1977), and an outdoor exhibition at Ward's Island in New York (1979).

Blue Moon,1970
Steel (painted blue)
60 × 22 × 12″

Ex, 1971
Wood and metal
120 × 72 × 20 ″

Four Poles and Light,1973
Aluminum
50′ × 50′ × 50′

DAME BARBARA HEPWORTH
(born Wakefield, Yorkshire, England, 1903; died St. Ives, Cornwall, England, 1975)

Hepworth studied on scholarship at the Leeds School of Art (1901 – 21) and the Royal College of Art in London (1921 – 24), where she knew Henry Moore. In Italy from 1924 to 1926, she learned to carve directly in stone from Ardini, but it was her meeting with Arp, and especially with Brancusi in the early '30s, that inspired her and determined the subsequent direction of her work toward an abstract conception of solid and void contained within a single, comprehensive form, usually carved in stone or wood. The sculptor also became an accomplished painter, writer, and designer of theater sets. She was a co-founder, with Naum Gabo, Adrian Stokes, and Bernard Leach, of the Penwith Society of Arts in Cornwall (1949).

In her earliest exhibitions, Hepworth showed in London with her first husband, John Skeaping, in 1927, 1928, and 1930. In 1932 and 1933 she had joint shows with Ben Nicholson, who later became her second husband, and in 1937 began a long career of one-person shows in London and elsewhere. Retrospectives of her work have taken place at the Temple Newsam in Leeds (with John Nash, 1943), the Wakefield City Art Gallery in Yorkshire (1951), the Whitechapel Art Gallery in London (1954 and 1962), the Martha Jackson Gallery in New York (1955 – 56), the Moderna Museet in Stockholm (1964), the Rijksmuseum Kröller-Müller in Otterlo, the Netherlands (1965), the Tate Gallery in London (1968), and the Hakone Open Air Museum in Japan (1970). She represented England in the Venice Biennales of 1950 and 1968.

Several important prizes were awarded Hepworth, including the Gold Medal for Sculpture of the Hoffman Wood Trust in Leeds (1951), second prize for the Political Prisoner Competition at the Institute of Contemporary Art in London (1953), the Grand Prize of the Fifth Bienal of São Paulo (1959), and the Foreign Minister's Award at the Tokyo International Art Exhibition (1963). In England she received the title Dame Commander of the Order of the British Empire in 1965, and in the same year was named a trustee of the Tate Gallery. In the United States she became an honorary member of the American Academy of Arts and Letters as well as the National Institute of Arts and Letters in 1973.

Among Hepworth's commissions is a memorial to Dag Hammarskjold at the Secretariat Building in New York (1963). Her works can be found in the collections of the Barbara Hepworth Museum in St. Ives, the National Gallery of Canada in Ottawa, the Arts Council of Great Britain, the Art Gallery of Victoria in Melbourne, the Hirshhorn Museum and Sculpture Garden in Washington, D.C., and many other museums.

Pavan, 1956
Bronze
29½ × 43 × 21″

Square Forms with Circles, 1963
Bronze (green patina)
102¼ × 60½ × 9⅝″

HANS HOKANSON
(born Malmö, Sweden, 1925)

Hokanson taught himself art by copying works from post cards. He traveled through Europe after World War II and in 1951, after emigrating to the United States, studied drawing at the Finch-Warshau Studios in Los Angeles. Later, at the Art Students League in New York, Hokanson studied anatomy and color.

As a journeyman in the carpenters' guild, Hokanson worked on the construction of houses, and in 1956 he became a technician for the Museum of Primitive Art in New York, which stimulated his interest in the primitive art of Africa and the South Seas. His association with Judith and Julian Beck of the Living Theater encouraged him to branch out into stage design and lighting.

Hokanson's first one-person show was held at the Fishbach Gallery in New York in 1965. He has had numerous exhibitions at Guild Hall in Southampton, Long Island, where he resides, and was awarded First Purchase Prize in 1975 in their "Invitational Artists of the Region Exhibition."

At present Hokanson is involved in carving large sculptures from American black walnut. Of his work, Hokanson stated, "I still play with subject matter for the sculptures: rape and seduction represented in coiled serpents, hats, compressed, sensuous shapes, spirals. And lastly I have to confess to a material obsession with the characteristic of wood."

Helixikos Number 3, 1969
Bronze
36½ × 25 × 22″

ALFRED HRDLICKA
(born Vienna, Austria, 1928)

The marble and brass sculptures of Hrdlicka, as well as his etchings, reflect the experience and sensibility of an artist who lived through the Holocaust. His huge figures, often without head or limbs, reflect this preoccupation.

Between 1953 and 1957 Hrdlicka studied with Fritz Wotruba, Austria's leading sculptor. Previously he studied at the Academy of Fine Art in Vienna (1946 – 53).

He has exhibited individually at the Zedlitzhalle (1960) and the Künstlerhaus

(1962), both in Vienna, at Marlborough Fine Arts in London (1967), and at the Kestner Gesellschaft in Hanover, West Germany (1974). He has also participated in numerous group shows, including "The Object in Austrian Painting and Sculpture," Vienna (1961); the Venice Biennale of 1964; the 5th Biennial in Tokyo (1966); the 6th International Biennale of Sculpture in Carrara, Italy (1969); and the Biennale in Middelheim, Antwerp (1973).

Hrdlicka has received several awards for his print-making, including the first international prize of the Biennale of Graphic Works, Ljubljana, Yugoslavia (1963); the City of Vienna prize (1964); the "Bianco e nero" prize, Lugano (1964); and the prize of the 5th International Biennale Exhibition of Prints, Tokyo (1966).

Golgatha, 1963
Marble
87¾ × 23 × 19½"

JIM HUNTINGTON
(born Elkhart, Indiana, 1941)

Huntington attended Indiana University in 1958 – 59 and El Camino College in California in 1959 – 60. His early sculptures elegantly combine wood and steel to form narrow vertical structures. In more recent works he incorporates large sections of bluestone or granite with steel plates placed in the stone channels of the works.

Huntington has shown individually at the Hayden Gallery of the Massachusetts Institute of Technology in Cambridge (1968) and at the Max Hutchinson Gallery in New York (1971). His work has also appeared in group exhibitions at the Corcoran Gallery of Art, Washington, D.C. (1965 and 1967); the Whitney Museum of American Art, New York (1968 – 69); the David McKee Gallery, New York (1976); and the Laguna Gloria Gallery, Austin, Texas (1977 – 78).

In 1965 Huntington received the Grand Prize in the Sheraton-Boston Competition and the Blanche Colman Award, also in Boston.

Inheritor (for Jake), 1978
Granite and stainless steel
83 × 85 × 65"
Anonymous loan

JEROME KIRK
(born Detroit, Michigan, 1923)

Kirk received his B.S. from the Massachusetts Institute of Technology in Cambridge. Working in the Constructivist tradition, he is best known for his kinetic sculptures in aluminum, brass, and stainless steel.

His commissions include works for TRW, Inc., in Redondo Beach, California (1968 – 69), the Civic Plaza in Phoenix, Arizona (1971), and the Monterey Cultural Center in California (1977). He has had one-perosn shows at the Gallery of Contemporary Art in Taos, New Mexico (1973), the Elaine Horwitch Gallery in Scottsdale, Arizona (1975), the Benjamin Galleries in Chicago (1975), and the Aldrich Gallery in San Francisco (1976), and has participated in group shows at the M.H. de Young Museum in San Francisco (1965), the Indianapolis Museum of Art (1976), and the Baltimore Museum of Art (1977).

Orbit, 1972
Stainless steel
12' × 72" × 72"

GRACE KNOWLTON
(born Buffalo, New York, 1932)

A 1954 graduate of Smith College in Northampton, Massachusetts, Knowlton studied painting with Kenneth Noland and Vatclav Vytlacil, drawing and sculpture with Lothar Brabanski and steel welding with Martin Chirino. She attended the Corcoran School of Art and the American University in Washington, D.C., was assistant to the Curator of Graphic Arts at The National Gallery of Art (1954 – 57), and taught at the Arlington County Public Schools (1957 – 60).

Working in clay, concrete, and polyester, Knowlton shapes large spheres resembling boulders. She also made a film on ceramics, "Midnight Raku," and in 1971 was commissioned to make pottery prototypes for the Appalachian Workshops under the auspices of the American Federation of Arts.

One-person shows of her work have been held at the Hinckley and Brohel Gallery (1967) and Henri Gallery (1973), both in Washington, D.C.; Spectrum Gallery (1971) and Razor Gallery (1974), both in New York. Her works are in the collections of the Newark Museum, New Jersey; Lloyds of London, Washington, D.C.; and the J. Patrick Lannan Museum, Palm Beach, Florida.

Spheres, 1973 – 75
Clay, resin and fiberglass
Large sphere 96" diameter
Small spheres 36" diameter

JOSEPH KONZAL
(born Milwaukee, Wisconsin, 1905)

Konzal studied in New York at the Art Students League with Max Weber and Robert Laurent (1926 – 31), at the Layton School of Art (1927) and the Beaux Arts

Institute of Design (1928 – 30). He taught at the Brooklyn Museum Art School (1949 – 71), Adelphi University in Garden City (1954 – 71), Queens College in New York (1966 – 69), the Newark School for Fine and Industrial Arts in New Jersey (1960 – 67), and Kent State University in Ohio (1971 – 76).

In his large steel sculptures, Konzal balances vertical interlocking sections in open space. Monumental works have been commissioned from him by the Blossom Music Center, Cuyahoga Falls, Ohio (1972), and by the General Services Administration for a federal building in Dayton, Ohio (1977).

In New York, Konzal showed regularly at the Bertha Schaefer Gallery from 1960 to 1971, and at the André Zarre Gallery in 1978. He has had retrospectives at Adelphi University (1965) and Kent State University (1971). Important group exhibitions in which he has participated include six Whitney Annuals between 1948 and 1968, and shows at the Museum of Modern Art, New York (1958), the New Jersey State Museum, Trenton (1965 through 1971), and the Cleveland Museum of Art (1972 and 1975). Individual works of Konzal are in the Tate Gallery in London, the New School for Social Research in New York, the Whitney Museum of American Art in New York, and the New Jersey State Museum in Trenton, among others. He has been awarded the Guggenheim Foundation Fellowship (1965 – 66) and prizes for the John F. Kennedy Memorial Cultural Center and the Sculpture Competition for the Nassau County Court House (both 1968).

Champion, 1965
Steel (painted black)
67½ × 23½ × 35"

Simplex, 1970
Cor-ten steel
91 × 55½ × 62"

KOSSO (ELOUL)
(born Murom, Russia, 1920)

Kosso emigrated with his family to Israel in 1924 and received his schooling in Tel Aviv. He attended the Art Institute of Chicago between 1939 and 1943 and now lives and works in the United States. He has exhibited extensively throughout Europe, Israel, and North America, particularly Canada. His work appeared in the Venice Biennale of 1959 and the Carnegie Internationals of 1964 and 1967 in Pittsburgh. As a printmaker he has exhibited jointly many times with his wife, Rita Letendre, and has participated in the 18th Annual Print Show at the Brooklyn Museum (1972) and the 4th Annual Printmakers Showcase in Ottawa (1972).

Among Kosso's many monumental sculpture commissions are the concrete and stainless steel *Hardfact* at California State University, Long Beach (1965); the painted steel *Thunder* for the J. Patrick Lannan Foundation, Palm Beach (1967); the *Morning Night* fountain in Los Angeles (1968); and the environmental *Now* at Fanshawe College in London, Ontario (1971).

Genesis, 1964
Limestone
46¼ × 48 × 31"

SOL LEWITT
(born Hartford, Connecticut, 1928)

LeWitt received his B.F.A. from Syracuse University, New York, in 1949. While serving in the U.S. Army in Japan and Korea, he had an opportunity to study oriental shrines, temples and gardens. In 1953 he attended the School of Visual Arts, New York City, where he became an instructor. He also taught at the Peoples Art Center, Cooper Union School and New York University.

One of the founders of the Minimal and Conceptual movements, LeWitt uses the basic geometric forms of the square and the cube in his sculptures and drawings. His early wood constructions of the mid-sixties were followed by modular cube structures in 1965 and serial works in 1967.

He worked for *Seventeen Magazine* as a photostat operator and production worker from 1954 to 1955, and as a graphic artist for architect I.M. Pei in 1955 – 56. For the next three years he painted and did graphic design work for a commercial firm. From 1960 – 65 he worked for the information and Book Sales desk at the Museum of Modern Art.

His first three-dimensional works were displayed at Saint Mark's Church, New York City, in a group show in 1963. Other individual and group exhibitions in which he participated were held at the Stadtisch Museum, West Germany, 1969, Fondation Maeght, Saint Paul, France, 1970, John Weber Gallery, New York, 1973, Stedelijk Museum, Amsterdam, 1975, and the National Gallery of Victoria, Melbourne, Australia, 1977.

His first wall drawings were shown at the Paula Cooper Gallery, New York City, in 1968. LeWitt also showed his work at the Institute of Contemporary Art, Boston, Massachusetts, 1966, the Jewish Museum, New York City, 1966, and the Gemeentemuseum, The Hague, Netherlands, 1968. During 1978 the artist was honored with a retrospective at the Museum of Modern Art, New York City.

An accomplished writer and book-maker, LeWitt has published two statements, "Paragraph on Conceptual Art" (*Art Forum,* June 1967) and "Sentences on Conceptual Art" (*Art Language,* May 1969). He also designed the book on Eva Hesse written by Lucy Lippard.

Five Modular Units, 1970
Steel (painted white)
66" × 66" × 24'

ALEXANDER LIBERMAN
(born Kiev, Russia, 1912)

With his family, Liberman emigrated from Russia to London in 1921 and then to Paris in 1924. After attending the Ecole Des Roches (1924 – 30), he studied painting with André Lhote (1929 – 31) and architecture with Auguste Perret (1930 – 32) while also attending the Ecole des Beaux-Arts et Architecture in Paris (1931 – 32). The diversity of Liberman's interests was apparent from the beginning of his career in Paris, where he became art director of *Vu* magazine (1933 – 37) and was also engaged in designing for the stage and directing a film on painting for the Louvre Museum. In 1941 he emigrated to New York, where he joined *Vogue* magazine, becoming its art director in 1943 and editorial director for Condé Nast publications in 1962. An accomplished sculptor, painter, photographer, and graphic designer, Liberman has concentrated during the last ten years on monumental sculptures in steel and abstract paintings.

In the United States Liberman showed his work first in a group exhibition of young painters at the Guggenheim Museum in 1954. He has since had numerous one-person shows throughout the world and retrospectives at the Corcoran Gallery of Art in Washington, D.C. (and the Houston Museum of Fine Arts, 1970), the Honolulu Academy of the Arts (1972), and the Storm King Art Center (1977). He showed regularly at the Betty Parsons Gallery in New York from 1960 to 1969 and has been represented since 1967 by the André Emmerich Gallery.

Liberman was awarded the gold medal for design at the Paris International Exhibition in 1937 and a citation from the American Iron and Steel Institute in 1975. He also holds the French Legion of Honor. His published books include *The Artist in His Studio* (1960) and *Greece, Gods, and Art (1968).*

Eve, 1970
Steel (painted orange)
16'3" × 44' × 24'8"

Ascent, 1970
Steel (painted orange)
16' × 20' × 25'
Anonymous loan

Adonai, 1971
Steel
35' × 50' × 75'

In, 1973
Steel
40' × 53'
On loan from the artist

Iliad, 1974 – 76
Steel (painted orange)
36' high
On loan from the artist

HENRY MOORE
(born Castleford, Yorkshire, England, 1898)

After serving in the British Army during the First World War (1917 – 19), Moore attended the Leeds College of Art (1919 – 21) and the Royal College of Art in London (1921 – 24), where he also taught until 1931 after a tour on fellowship of the art capitals of Europe in 1925. He also taught at the Chelsea School of Art in London (1933 – 39).

Moore continues the humanistic tradition of figurative sculpture, but transformed into a highly original modern idiom. In the 1920s he was profoundly influenced by the directness and massive presence of ancient Egyptian, African, and Pre-Columbian sculpture. Working in marble, granite, bronze, clay, wood, concrete, and other materials, Moore has, since the 1930s, conceived of sculpture as a total and dynamic interaction of interior space and exterior mass, leading at times to almost total abstraction. His themes have been basic ones — king and queen, mother and child, family groups, reclining figures — aligned with his own epic sense of nature. Moore is also known for his drawings, especially the group depicting figures in London air-raid shelters during the Second World War.

Moore's first one-person show was held at the Warren Gallery in London in 1928. He then showed regularly in London at the Leicester Gallery from 1931 through 1960 and at Marlborough Fine Art from 1961 through 1971. Major retrospectives of his work have been held by the Museum of Modern Art in New York (and other U.S. museums, 1946 – 47); the Wakefield City Art Gallery in Yorkshire (and European tour, 1949 – 50); the Tate Gallery in London (1951); the Kunsthalle in Mannheim, Germany (and European tour, 1954); Trinity College in Dublin, Ireland (1966); the National Museum of Art in Tokyo (and tour, 1969); the Forte di Belvedere in Florence, Italy (1972); the Wilhelm-Lehmbruck Museum in Duisburg, Germany (1974); and the Orangerie in Paris (1977). Moore has received numerous

awards, including the International Prize for Sculpture at the Venice Biennale of 1948 and second prize at the Carnegie International in Pittsburgh (1958).

Most of the world's museums own works by Moore. He has also created more monuments for public and private commissions than any other contemporary sculptor. These commissions include those for the headquarters of the London underground in St. James's Park (1928), the 1951 Festival of Britain, the UNESCO building in Paris (1959 – 60), Lincoln Center in New York (1965), the Hakone Open Air Museum in Japan (1969 – 70), and the National Gallery of Art in Washington, D.C. (1977 – 78).

Reclining Connected Forms, 1969
Bronze (green patina)
38 × 87¾ × 52″

FORREST WARDEN MYERS
(born, Long Beach, California 1941)

Myers studied at the San Francisco Art Institute and later taught there (1967) and at the School of Visual Arts in New York (1968). His works in brass, concrete, stainless or Cor-ten steel can be found in the Museum of Modern Art in New York, the American Embassy in Mexico City, the J. Patrick Lannan Museum in Palm Beach, Florida, and many other collections. He has shown in major exhibitions at the Los Angeles County Museum of Art (1968), the Whitney Museum of American Art in New York (1968 and 1972), and the Philadelphia Museum of Art (1968). In 1968 he received an award from the American Steel Institute and the Aero Space Industries Design Award.

Mantis, 1968 – 70
Cor-ten steel and stainless steel
99⅜ × 120 × 120″

Four Corners, 1969 – 70
Brass, stainless steel, Cor-ten steel and concrete
120 × 120 × 120″

MARIO NEGRI
(born Tirano, Italy, 1916)

After attending architectural school in Milan, Negri was called into military service and later survived two years in a German concentration camp. He turned to sculpture after the War and had his first one-person show, an exhibition of drawings, at the Galleria de L'Isole in Genoa (1946). He later showed at the Milione Gallery in Milan (1957) and has participated in the Venice Biennale and the Rome Quadriennale. In the United States he has shown in the Carnegie International in Pittsburgh (1963) and the Akron Arts Institute in Ohio. His work

can be found in the Rijksmuseum Kröller-Müller in Otterlo, The Netherlands; the Art Institute of Chicago; the Baltimore Museum of Art; the Stedelijk Museum in Amsterdam; and many other museums.

Uomo Seduto, 1967
Bronze
38½ × 27⅞ × 41″

ISAMU NOGUCHI
(born Los Angeles, California, 1904)

Noguchi's father, Yonejiro (Yone) Noguchi was a poet from Japan, and his mother , Léonie Gilmour, an American writer and teacher. His childhood was spent in Japan, and upon his return to the United States in 1919, Noguchi apprenticed to Gutzon Borglum in Connecticut. He was a student in New York City at Columbia University and also attended the Leonardo da Vinci Art School, where he had his first one-person show in 1924. During 1927, while on a Guggenheim Fellowship in Paris, he studied at the Académie Grande Chaumière and the Collarosi School, assisting Constantin Brancusi. In Paris he met Alexander Calder, Stuart Davis, Morris Kantor and Andre Ruellan.

Over the next several years, he made portrait heads of various personalities including George Gershwin, Martha Graham and Buckminster Fuller. He studied brush drawing in Peking with Chi Pai-Shi and pottery in Japan with Uno Jinmatsu.

During the 1930s and 40s, Noguchi created a total playground environment, entitled "Play Mountain," for New York City, which was never realized. He designed his first ballet set in collaboration with Martha Graham and was commissioned to do a bas relief for Rockefeller Center in New York City. He also completed a mural on the history of Mexico for a public marketplace in Mexico City.

Noguchi's concept of abstract, interrelated pieces of sculpture dates from the 1920s. In the years ahead, the artist continued to develop marble sections of thin, vertical, interlocking units. These were followed by variations of the same concept as demonstrated in his granite pieces of the 1970s which fit together like puzzles. In addition to working with bronze, granite, steel, and clay, he also skillfully combines stone and wood to create his sculptures.

Another aspect of Noguchi's work is his concern with creating a total environment, as realized in his gardens. In 1951 – 52 he completed two gardens for Keio Univeristy and the Readers Digest in Japan. Working in cooperation with various architects in the late 1950s

and 60s, Noguchi designed sculpture gardens for the UNESCO building in Paris, the Bienecke Library at Yale University, Connecticut, Chase Manhattan Bank, New York City, the Billy Rose Sculpture Garden, Israel, and in 1974 – 79 the Dodge Fountain and Plaza, Detroit, Michigan.

The artist has had retrospectives in New York City at the Museum of Modern Art (1947 and 1952) and the Whitney Museum of American Art (1968), in addition to the Walker Art Center, Minneapolis, Minnesota, and U.S tour (1978 – 79) among others.

Momo Taro, 1977
Granite
96″ × 35′ 2″ × 22′ 8″

JOEL LEONARD PERLMAN
(born New York City, 1943)

Perlman received a B.F.A. at Cornell University (1965), an M.F.A. at the University of California, Berkeley (1967), and also attended the Central School of Art and Design in London (1964 – 66). He taught at Bennington College, Vermont (1969 – 72), and also in New York at the School of Visual Arts (1973) and Fordham University (1974). His work appeared in the Whitney Biennial of 1973 and he has been represented by the André Emmerich Gallery in New York since 1973.

Working in steel and aluminum, Perlman has been influenced in style and technique by Brian Wall and David Smith. His large welded steel structures can be found in the collections of the Aldrich Museum of Contemporary Art in Ridgefield, Connecticut, and R T K L, Inc., in Baltimore, for which he was given the H. U. D. award in 1972.

Night Traveler, 1977
Steel (painted black and brown)
120 × 51 × 48″

KARL PFANN
(born Eisenstadt, Austria, 1921)

Pfann attended the Masters' School of Painting in Vienna from 1939 to 1942. From 1960 to 1961, Pfann took painting with Vatclav Vytlacil, and sculpture at the Academy of Visual Arts with Fritz Wotruba (1962 – 63). He also studied sculpture at the Symposium in St. Margarethen during 1960 – 63.

The artist created his sculptures in both abstract and realistic compositions. He works in various types of stone and specializes in limestone. Pfann has had one-person and group exhibitions in his native Vienna. His sculptures are in public and private collections in the United States and Europe.

Growing Forms, 1960
Limestone
111½ × 58 × 49″

JOSEF PILLHOFER
(born Vienna, Austria, 1921)

After attending the School of Arts and Crafts in Graz, Austria, Pillhofer became a student of Fritz Wotruba at the Vienna Academy in 1947, and again from 1951 to 1954. He was even more strongly influenced, however, by Brancusi, whom he met, along with Laurens and Giacometti, while studying in Paris in 1950 – 51. Gradually his abstractions developed toward an architectural style, stressing strong, vertical lines. Pillhofer's work has been shown prominently in Vienna and Paris. In 1954 and 1956 he participated in the Venice Biennale and was honored with a retrospective at the Santee Landwar Gallery in Amsterdam in 1959.

Man in the Quarry, 1960
Lime/Sandstone
101½ × 37 × 36″

Untitled
Marble
49½ × 19″

GEORGE RICKEY
(born South Bend, Indiana, 1907)

Rickey moved to Scotland with his family in 1913. He attended Oxford University from 1926 to 1929 and received his M. A. when he returned there in 1941. He also studied at the Académie André Lhote and with Fernand Léger at the Académie Moderne in Paris (1929 – 30). After serving in the U.S. Air Force during World War II (1941 – 45), he returned to his studies in the United States, at New York University, the University of Iowa, and the Institute of Design in Chicago. Rickey served as artist-in-residence at Olivet College in Michigan (1937 – 39), and taught at Muhlenberg College in Allentown, Pennsylvania (1946 – 48), Indiana University in Bloomington (1949 – 55), Tulane University in New Orleans (1955 – 61), and the Rensselaer Polytechnic Institute in Troy, New York (1961 – 1966).

Originally a painter, Rickey created his first kinetic sculptures in 1945, while still in the service. These small works are made of various metals. He began working on larger outdoor sculptures in stainless steel after moving to East Chatham, New York, in 1960. They incorporate lines, squares, and rectangles, which are gently moved through space by the wind. Rickey states, "My concern is the move-ment, not the form. Or rather, I should say that movement is the form".[1]

The first one-person show of Rickey's sculpture took place at the John Herron Art Museum in Indianapolis in 1953. He has shown regularly at the Staempfli Gallery in New York since 1964 and has had individual shows at the Galerie Springer in Berlin (1962), the Galerie Espach in Amsterdam (1974), the Galerie Buchold in Munich (1974), and elsewhere. His work has also appeared in important group shows at The Metropolitan Museum of Art in New York (1951), Battersea Park in London (1963), Documenta III in Kassel, Germany (1964), the Hayward Gallery in London (1970), the Greenwich Art Council in Connecticut (1976), and the Gallery Skulima in Berlin (1979). Major retrospectives of his work have been presented by the Corcoran Gallery of Art in Washington D. C. (1966), the University of California at Los Angeles (and U. S. tour, 1971 – 72), and the Guggenheim Museum in New York (1979).

In 1937 Rickey received the first Carnegie grant given to an artist. He was also awarded an honorary Doctorate of Fine Arts from Knox College in Illinois (1970), and the Skowhegan School of Painting and Sculpture Medal (1973). An authority on Constructivism, the artist lectures extensively on this subject and in 1967 published the book, *Constructivism: Origins and Evolution.*

Six Lines in a T, 1965 – 66
Stainless steel
78½″ × 10′ 8″ × 30½″

Two Planes Vertical-Horizontal II, 1970
Stainless steel
14′ 7⅝″ × 10′ 5″ × 75″

[1] Grace Glueck, "Rickey Sculptures Adorn City Plaza," *The New York Times,* April 23, 1975, sec. 3, p. 28.

HANS SCHLEEH
(born Konigsfeld, Germany, 1928)

Schleeh studied in Germany and in 1951 settled in Montreal, Canada. He works figuratively and abstractly in marble, granite, bronze, and various other metals. After traveling to France and Switzerland in 1963 – 64, he was given commissions to do sculptures for the Basilica of Ste. Anne de Beaupré and other churches. A one-person exhibition at the Dominion Gallery in Montreal in 1960 was followed by a number of group exhibitions in which he participated, including shows at the New Art Center Gallery in New York (1962), the Kunsthalle in Düsseldorf, Germany (1964), the Musée Rodin and Salon de la Jeune Sculpture in Paris (1966), and Expo in Montreal (1967).

Dying Swan, 1954
Marble
35 × 30½ × 28½″

The Family, 1970
Granite
46 × 16½ × 12¾″

DAVID SMITH
(born Decatur, Indiana, 1906; died Bennington, Vermont, 1965)

Smith took a correspondence course in cartooning while still in high school. He studied for a year at the University of Ohio (1924) and in 1926 moved briefly to Washington, D. C. He then moved to New York where he studied painting at the Art Students League with Richard Lahey and John Sloan until 1932. He was also a private student of Jan Matulka (1928 – 29), who encouraged a keener interest in contemporary European art. Smith's work as a welder, at the Studebaker automobile plant in South Bend, Indiana (1925), and at the American Locomotive Company in Schenectady, New York (1942 – 44), was appropriate to his sculptural methods. He taught sporadically, at Sarah Lawrence College in Bronxville, New York (1948 – 50), the University of Arkansas (1953), the University of Indiana (1954), the University of Mississippi (1955), and Bennington College in Vermont (1964).

Smith did not become a sculptor until 1932, when he began to make "constructions" and abstract figures with wood, wire, plaster, nails, bronze, coral, iron, steel, and other traditional and found materials. From 1934 through 1940 he fabricated works inspired by Picasso, Gonzales, the Surrealists, and others at the Terminal Iron Works in Brooklyn. In 1940 Smith moved permanently to Bolton Landing in northern New York with his wife, the painter Dorothy Dehner, and continued to work in steel, iron, and bronze. The 1950s saw an increase in the size of the sculptures, so that eventually he began to place them in the fields around his studio. At this time he was working on the Agricola, Sentinel, and Tank Totem series. In 1962, at the invitation of the Italian metallurgy industry, Smith created a group of twenty-six sculptures, using found industrial metal, in an abandoned factory at Voltri, near Genoa. All the works, known as the "Voltri" series were shown at the fourth Festival of Two Worlds at Spoleto in 1962. At the time of his death he was working on the monumental Cubi series, in which cubic blocks of stainless steel are combined in intricately balanced compositions.

Smith's first one-person show of sculpture took place at Marian Willard's East River Gallery in New York City (1938). He showed at the Willard Gallery until 1953 and joined the Marlborough-Gerson Gallery in 1964. Included among his major museum shows are those at the Walker Art Center in Minneapolis (1952), the Contemporary Arts Center in Cincinnati (1954), the Museum of Modern Art in New York (1957; 1961 U. S. tour; 1963 U.S. tour; 1966 international tour), the Los Angeles County Museum of Art (1965), the Fogg Art Museum in Cambridge, Massachusetts (1966), the Guggenheim Museum in New York (1969, and U. S. tour), and the Storm King Art Center in Mountainville, New York (1976). Smith's work has appeared in numerous group shows, including the Venice Biennales of 1954 and 1958, the São Paulo Bienal of 1959, Documenta II and III in Kassel, Germany (1959 and 1964), and Monumenta in Newport, Rhode Island (1974). His works can be found in most of the world's major museums.

The Guggenheim Foundation Fellowship was awarded Smith in 1950 – 51 and the Brandeis University Creative Art Award in 1964. He rejected the prize of the Carnegie International in 1961. In 1965 he was appointed to the National Council on the Arts.

Sitting Printer, 1954
Bronze (green patina)
87¼ × 15¾ × 16″

The Iron Woman, 1954 – 56
Steel (painted green)
88 × 14½ × 16″

Five Units Equal, 1956
Steel (painted green)
73¼ × 16¼ × 14¼″

Personage of May, 1957
Bronze (green patina)
71⅝ × 32 × 19″

Portrait of a Lady Painter, 1957
Bronze (green patina)
63⅝ × 59¾ × 12½″

Albany I, 1959
Steel (painted black)
24¾ × 25¼ × 7¼″

XI Books III Apples, 1959
Stainless steel
94 × 31¼ × 13¼″

Raven V, 1959
Steel and stainless steel
58 × 55 × 9½″

Study in Arcs, 1959
Steel (painted pink)
132 × 115½ × 41½″

Tank Totem VII, 1960
Steel (painted dark blue and white)
84 × 36½ × 14¼″

Three Ovals Soar, 1960
Stainless steel
11′ 3½″ × 33″ × 23″

Voltron XX, 1963
Steel
62¼ × 37½ × 26½″

Becca, 1964
Steel
78 × 47½ × 23½″

KENNETH SNELSON
(born Pendelton, Oregon, 1927)

Snelson studied engineering at the University of Oregon (1946 – 48) and Oregon State University (1949). He also attended Black Mountain College in North Carolina, where he studied with Josef Albers, Buckminster Fuller, and William de Kooning, the Institute of Design in Chicago (1950), and the Atelier Fernand Léger in Paris (1951).

His towering aluminum and stainless steel sculptures are supported by cables from within. Regarding his work, Snelson says, "My concern is with nature in its fundamental aspect; the patterns of physical forces in space. I try to reveal these patterns in my sculpture as directly as possible with linear material under tension and compression."

In recent years Snelson has lived partly in Germany, where he had several one-person shows, most recently in 1977, in Hamburg and Berlin. Other individual exhibitions have been presented in New York City at Bryant Park (1968) and Waterside Plaza (1974 – 75); at the Rijksmuseum Kröller-Müller in Otterlo, The Netherlands (1969); the Wilhelm-Lehmbruck Museum in Duisburg and the Nationalgalèrie in Berlin, Germany (1977). Snelson received a National Endowment for the Arts grant for his exhibition "Portrait of an Atom" at the Maryland Science Museum in Baltimore (1979).

The artist is also an accomplished photographer and writer. In 1979 he had a photographic exhibition at the Sonnabend Gallery in New York. His publications include "A Design for the Atom" (*Industrial Design Magazine,* February 1963) and "Model for Atomic Forms" (October 1966, U. S. Patent Office).

In 1974 Snelson was given the Reynolds Metal Sculpture Award, as well as the National Endowment for the Arts Iowa Sculpture Competition Award. He received the DAAD Fellowship for residence in Berlin in 1975.

Free Ride Home, 1974
Aluminum and stainless steel
30′ × 60′ × 60′

RICHARD P. STANKIEWICZ
(born Philadelphia, Pennsylvania, 1922)

One of the first sculptors to use iron and steel in the tradition of Picasso and Gonzalez, Stankiewicz transformed found objects, in his pieces of the 1950s, into inventive, often humorous works of art. Since the mid-60s he has worked with more massive geometric, especially cylindrical, forms.

Stankiewicz studied at the Hans Hofmann School of Fine Arts in New York (1948 – 50), and with Fernand Léger and Ossip Zadkine in Paris (1950 – 51). Since 1967 he has been a professor of art at the State University of New York in Albany.

In 1952 Stankiewicz organized, with eleven other artists, the Hansa Gallery in New York, which was also the site of his first one-person show in 1953. In recent years he has shown regularly at the Zabriskie Gallery. His work has also been included in exhibitions at the Venice Biennale of 1958, the Carnegie Institute in Pittsburgh (1958 and 1961 – 62), the Moderna Museet in Stockholm (1962), and the National Gallery of Victoria in Melbourne, Australia (1969), among others. The artist is represented in many museums, including the Museum of Modern Art in New York, the Albright-Knox Art Gallery in Buffalo, New York, the Art Institute of Chicago, and the Centre Beaubourg in Paris.

Stankiewicz received the Ford Foundation Artist-in-Residence Award in 1965 and is a member if the National Institute of Arts and Letters.

Austrialia No. 9, 1969
Steel
89 × 36 × 48″

DAVID STOLTZ
(born Brooklyn, New York, 1943)

Stoltz attended the Art Students League in New York from 1963 to 1965, where he studied drawing and sculpture under John Hovannes and José de Creeft. He also went to the Skowhegan School of Painting and Sculpture in Maine and Pratt Center for Contemporary Graphics in New York (1966 – 68), where he later became an instructor. He combines hand forging and machine fabrication in his abstract steel sculptures and is an accomplished etcher and lithographer.

Works by David Stoltz are in the museum collections of Williams College and Smith College in Massachusetts, as well as other public and private collections. A selection of exhibitions includes a one-person show at the Portland Museum of Art in Maine (1973) and group shows at the American International Sculptors Symposium (1974), and in New York at the André Emmerich Gal-

lery (1970) and the Nancy Hoffman Gallery (1975).

Stoltz was awarded the William Zorach Scholarship and apprenticed with Zorach from 1964 to 1966. He was also given a Pratt Scholarship in 1966 – 68.

Day Game, 1972
Steel
77" × 45" × 28' 7"

River Run, 1972
Steel
42" × 10' 1½" × 57"

TAL STREETER
(born Oklahoma City, Oklahoma, 1934)

Streeter received his M. F. A. in 1961 at the University of Kansas and also studied at the Colorado Springs Fine Arts Center with Robert Motherwell. For three years, he was assistant to Seymour Lipton in New York City (1957 – 1960). In 1971 Streeter went to Japan to learn the tradition of Japanese kite making, an experience that led to two books by the artist: *Red Line to the Sky: Notebook for a Contemporary Monument* and *The art of the Japanese Kite.*

Streeter has exhibited his large environmental sculptures of steel, paper, and cloth at museums and galleries throughout the United States and in Korea, where he taught graduate sculpture as a Fulbright professor. He was a sculptor-in-residence at Dartmouth College in Hanover, New Hampshire, in 1963, and a professor at Eiwa College in Shizuola, Japan, 1970 – 71. A former visiting artist at architect Paolo Solari's Arcosanti project and at Artpark in Lewiston, New York, he is currently chairperson of the III-D/Media at the State University of New York in Purchase, New York.

His large-scale works are included in the collections of the Smithsonian Institution in Washington, D.C.; Dartmouth College in Hanover, New Hampshire; the Museum of Modern Art in New York; the Wadsworth Atheneum in Hartford, Connecticut; the Newark Museum in New Jersey, and the High Museum of Art in Atlanta, Georgia. In 1977 Streeter collaborated with dancer Douglas Dunn on a commission for the American Dance Festival at Connecticut College. His awards include the SUNY International Studies Grant, for Japan (1969).

Endless Column, 1968
Steel (painted red)
62' 7" × 72" × 84½"

MICHAEL CULLEN TODD
(born Omaha, Nebraska, 1935)

Todd attended the University of Notre Dame in South Bend, Indiana until 1957 and received his M.F.A. at the University of California in 1959. He was an instructor at Bennington College in Vermont from 1966 to 1968 and an assistant professor of sculpture at the University of California, San Diego in 1968.

His sculptures of steel and aluminum can be found in the collections of the Whitney Museum of American Art in New York and the Los Angeles County Museum of Art. He has participated in group exhibitions at the Fondation Maeght in Saint Paul, France (1971), and the Zabriskie Gallery in New York (1974).

In 1959 Todd received the Woodrow Wilson Fellowship and in 1961 a Fulbright Fellowship in France.

Parenthetical Zero, 1970-71
Steel (painted brown)
84 × 96 × 84"

ERNEST TROVA
(born St. Louis, Missouri, 1927)

Without formal training, Trova first became a painter. In 1953 he moved to New York for a period and came under the influence of Willem de Kooning. But the tendency in his later work was away from expressionism toward a more classical and highly machined art, represented by the famous "Falling Man" series of sculptures, paintings and graphics, and the later, more abstract, monumental stainless steel sculptures in the "Gox" and "Canto" series.

Living and working in St. Louis, Trova showed at the St. Louis Annual from 1947 to 1961 and has been represented by the Image Gallery there since 1959. In New York he has shown regularly at the Pace Gallery since 1963. Other one-person shows have been presented in Zurich (1970), at the Israel Museum in Jerusalem (1971), and in Brussels (1972). He has also been in group shows in the Whitney Museum of American Art and the Museum of Modern Art, both in New York, at the Walker Art Center in Minneapolis, the Art Institute of Chicago, and many other museums.

Gox no. 4, 1975
Stainless steel
108 × 10"

WILLIAM TUCKER
(born Cairo, Egypt, 1935)

Tucker's education included the study of history at Oxford University (1955 – 58) and sculpture at the Saint Martin's School of Art and the Central School of Art and Design in London (1959 – 60). He was a professor of sculpture at the University of Western Ontario in 1976, and is currently teaching in New York at Columbia University and the New York Studio School. A sculptor in the con-structivist tradition, Tucker used fiberglass and wood in the mid-1960s and, more recently, metal to create abstract sculptures that emphasize simplicity of form and conjunction.

Exhibitions in which Tucker's work has appeared include the Paris Biennale of 1961, Documenta IV in Kassel, Germany (1968), the International Exhibition of Contemporary Art in 'Helsinki (1969), and a show at the Robert Elkon Gallery in New York (1979). He was honored by the British Arts Council in 1978 with a retrospective in Edinburgh, Scotland. His sculptures may be found in the collections of the Victoria and Albert Museum and the Tate Gallery in London, the Guggenheim Museum and the Museum of Modern Art in New York, the Louisiana Museum of Modern Art in Denmark, the Rijksmusem Kröller-Müller in Otterlo, The Netherlands, and elsewhere.

Among Tucker's awards are the Sainsbury Scholarship (1961), the Peter Stuyvesant Foundation Travel Bursary (1965), and the Gregory Fellowship in Sculpture of Leeds University (1968 – 70). Tucker, who is also an art critic and curator, published the book *Early Modern Sculpture* in 1974.

Six Black Cylinders, 1968
Steel (painted black)
55 × 94 × 58½"

DAVID VON SCHLEGELL
(born St. Louis, Missouri, 1920)

Before working at the Douglas Aircraft Corporation and serving in the U.S. Army Air Force during World War II (1943 – 44), von Schlegell was a student of engineering at the University of Michigan (1940 – 42). At the Art Students League in New York (1945 – 48), he studied painting with Yasuo Kuniyoshi, and he was for many years a student of his father, William von Schlegell.

It was not until 1961 that Von Schlegell became a sculptor. His early works were made of steamed wood, and he later used aluminum as a framework for his wooden pieces. In 1968 Von Schlegell made his first stainless steel sculpture at the University of California in Santa Barbara, where he was teaching. He was also an instructor at the School of Visual Arts in New York (1969 – 70) and now teaches master classes at Yale University in New Haven, Connecticut.

The first one-person exhibition of Von Schlegell's paintings was held at the Poindexter Gallery in New York in 1948. His sculpture was shown individually for the first time at the Stanhope Gallery in Boston and he has since shown at the Royal Marks Gallery (1966 – 67) and the

Pace Gallery (since 1974), both in New York. Von Schlegell's work has appeared in group shows at the De Cordova Museum in Lincoln, Massachusetts (1964), the Walker Art Center in Minneapolis (1971), the Middelheim Museum in Antwerp, Belgium (1971), the Art Institute of Chicago (1967), and elsewhere.

Among the institutions that own work by Von Schlegell are the Whitney Museum of American Art in New York, the Massachusetts Institute of Technology in Cambridge, Massachusetts, the Herbert F. Johnson Museum at Cornell University in Ithaca, New York, the Hirshhorn Museum and Sculpture Garden in Washington, D.C., and the Rhode Island School of Design in Providence.

In 1964 Von Schlegell won the Whitney Annual Award and the first prize of the Coleman Sculpture Award. He has also received the Carnegie International Purchase Prize (1967), a National Foundation of Arts grant (1969), and a Guggenheim Fellowship (1974).

Untitled, 1969
Stainless steel
96¼″ × 116″ × 13¼″ (vertical element)
64″ × 52″ × 81′ (horizontal element)

Untitled, 1969
Stainless steel and aluminum
120 × 16 × 14′9½″

Untitled, 1972
Aluminum and stainless steel
20 × 304′ × 16′

GERALD WALBURG
(born Berkley, California, 1936)

In addition to his large steel sculptures, Walburg has received recognition for his ceramics and watercolors. He studied at the California College of Arts and Crafts, California State University, and the University of California, and has been an associate professor of art at California State University since 1968.

Walburg has had one-person shows of sculpture at Sacramento City College (1966), the San Francisco Museum of Art (1969), the Royal Marks Gallery in New York (1969), Expo 70 in Osaka, Japan (1970), and San Jose State College (1970), among others. He exhibited watercolors at the Reese Paley Gallery in San Francisco (1971) and ceramics at the Museum of Contemporary Crafts in New York

(1965) and the Everson Museum in Syracuse, New York (1966 – 68). Large-scale sculptures are in the collections of the San Francisco Museum of Art, and the Oakland Museum, California.

Column, 1967
Cor-ten steel
25′ × 60″ × 60″

Loops V, 1971 – 72
Cor-ten steel
56″ × 16′ 8″ × 114″

ISAAK WITKIN
(born Johannesburg, South Africa, 1936)

Witkin moved to England in 1956 and now resides in New York. He studied with Anthony Caro at the St. Martin's School of Art in London (1957 – 60) and was assistant to Henry Moore from 1961 to 1963. In England he taught at the Maidstone College of Art, the St. Martin's School of Art, and the Ravensbourn College of Art and Design between 1963 and 1965. In the United States, he was an artist-in-residence at Bennington College in Vermont (1965) and has been affiliated with the Parsons School of Design in New York since 1975.

About his work, Witkin has said, "I am essentially a Baroque sculptor, in the sense that I avoid any strict adherence to the plan and to symmetrical layout. I aim to establish a freedom to move in multi-axial space, in a way that will draw the spectator in and around the sculpture, to experience different aspects of an evolving dynamic."[1] Steel and, more recently, bronze are the materials of his abstract sculptures.

Witkin has had one-person shows at the Rowan Gallery in London (1963), the Robert Elkon Gallery in New York (between 1965 and 1971), and the Waddington Gallery in London (between 1966 and 1968). He was given a retrospective of his work at the University of Vermont in Burlington in 1971. His work has also appeared in group shows at the Museum of Modern Art in New York (1965), the Hayward Gallery in London (1965), Sonsbeek in Holland (1966), the British Arts Council in London (1970), and the Nassau County Museum of Fine

[1]William C. Lipke, *Isaac Witkin Retrospective 1958 – 1971,* (Burlington, Vermont: George Little Press, Inc., 1971). p. 2.

Arts in Roslyn, New York (1978). Among the museums that own his work are the Hirshhorn Museum and Sculpture Garden in Washington, D.C., the Fine Arts Museum of the University of Sydney in Australia, and the Tate Gallery in London. Witkin shared first prize at the Paris Biennale of 1965.

Shogun, 1968
Cor-ten steel
75″ × 11′ × 120″

Masai, 1969
Steel (painted red)
49¾″ × 12′ 11½″ × 41″

Kumo, 1971
Cor-ten steel
16′ 3″ × 13′ 4″ × 12′ 2″

FRITZ WOTRUBA
(born Vienna, Austria, 1907; died 1975)

Wotruba learned engraving as a teenager at the School of Fine Arts in Vienna and later studied sculpture with Steinhof at the School of Anton Hanak. In 1930 he was associated with the Viennese architect Josef Hofmann and in 1937 with the French sculptor Aristide Maillol in Paris. Upon his return to Vienna from Switzerland in 1945, Wotruba began his career as a teacher at the Academy, where he became an important force in Austrian art. His works in bronze, marble, and stone were inspired by the human body, which, he has said, "never ceased to be the main source of my work: it was there at the begining and will be there at the end."

Wotruba's works have been shown throughout Europe and the United States. He first showed his work in 1931 at the Folkwang Museum in Essen, Germany, and has represented Austria in five Venice biennales, starting in 1948. He also participated at Documenta II in Kassel, Germany (1959). An important retrospective of the artist's work opened in 1977 at the Phillips Collection in Washington, D.C., accompanied by a catalogue documenting his sculpture, drawings, lithographs, etchings, costume and stage designs, and the architectural design for the Georgenberg Church in Vienna-Mauer.

Man Walking, 1952
Bronze
58½ × 19 × 24½″